A Glimpse of Erin

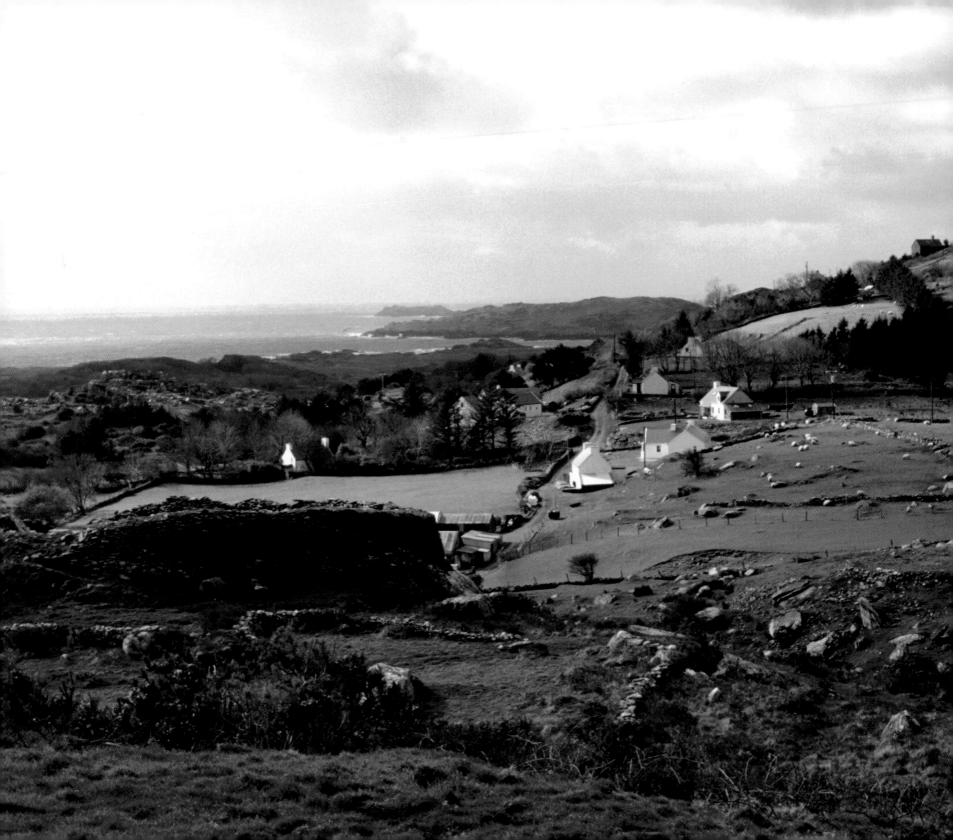

A Glimpse of Erin

Photography of John Francis McCarthy

Words of Sean O'Casey

FINGER LAKES PHOTOGRAPHY

TM

FINGER LAKES PHOTOGRAPHY, Skaneateles, New York 13152

ISBN 0-9623716-4-5
05 04 03 02 01 00 5 4 3 2 1

Design: ChaseDesign, Skaneateles, New York 13152
Printed in Hong Kong

He was staying too long in the Hallway

looking at the pictures. All done by others.

Very beautiful and strong, but all done by others.

He'd have to start now doing things for himself.

Create things out of his own life.

He'd begin to make pictures himself;

ay, pictures, too, that would be worth

hanging in the Hallway

for other people to see.

— Sean O'Casey

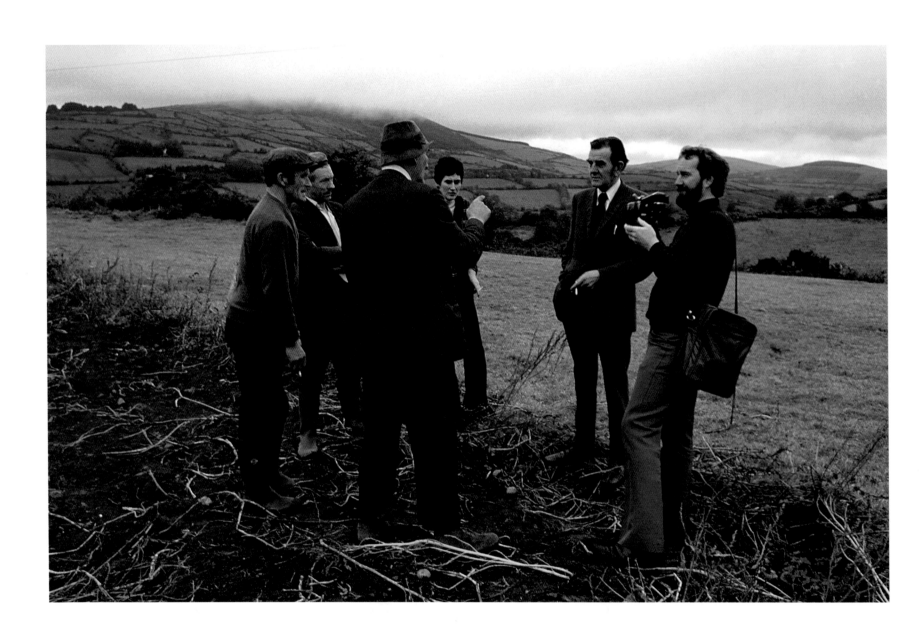

*P*reface

In 1977, I was invited to display photographs of Ireland at a Syracuse Stage production of *The Plough And The Stars*, Sean O'Casey's third major play. There I met Mrs. Eileen O'Casey and her daughter, Shivaun, who had traveled from New York City to see the show. I fondly recall viewing my photographs with them.

Soon after, I visited Mrs. O'Casey in New York to share an idea for a book with her. It was a crisp sunny day. Vivaldi resonated from a street vendor's stand near Central Park.

Mrs. O'Casey was gracious. I was star-struck. When I mentioned that I might ask David Krause, O'Casey's biographer and friend, to write an introduction, she quickly informed me that "Sean had asked George to do the same thing, and George told him to write his own unless he wanted people to buy his book just to see what George had written."

It took a few seconds to realize that I was hearing about George Bernard Shaw in the first person! Sean O'Casey idolized Shaw. Eileen O'Casey, his great friend, visited with him shortly before he died.

I visited nearly an hour with the woman O'Casey called "the pulse of my heart." On her words, vicariously from Shaw, I would write my own introduction. "Advice short and sweet, like an ass's gallop," O'Casey said of Shaw's counsel.

From the street vendor, I would buy Vivaldi to remember the sound and color and magic of the day.

Introduction

"I'm talking only to God now," O'Casey said toward the end. It was quite a concession from a man whose work incited a riot in the Abbey Theatre and was banned in Boston, who wrote twelve full-length plays, fifteen one-act plays, six volumes of autobiography and four volumes of poems, short stories, reviews and articles.

I discovered Sean O'Casey in Dublin in 1971 during a revival of his work at the Abbey. To me, this former construction laborer was the quintessential Irishman: witty, insightful, literate, sentimental, compassionate and tenacious. And one who had written about characters I had known all my life.

I was raised in an Irish family presided over by Katie Burke Donovan from Ballyboy, County Tipperary, who immigrated to Syracuse, New York around 1910. Katie had a great appreciation for literature and was forever sniping at me with recitations from Yeats, Keats, Eliot, Wordsworth, Wadsworth, Longfellow and Shakespeare until, in desperation, I would offer, "Was it Longfellow, Grandma?" hoping to distract her.

Syracuse's west side was named Tipperary Hill by Irish canal builders who found the rolling hills and lakes of upstate New York similar to Ireland and settled there. St. Patrick's Church is the heart of it— its Irishness manifest in a delicate stained glass shamrock window placed high above its sanctuary.

Irishness is also evident on the hill's first traffic signal. Installed in 1929, it features the green lens above the red.

As the story goes, shortly before the light arrived, Katie Donovan informed Alderman Huckle Ryan that her brother Owen Burke was just off the boat and available for the next job up in the city's department of transportation and safety. Katie reminded Ryan that his family was also from Ballyboy. And so it happened that Owen Burke, only hours in the country, chose the color green to lord above the color red, and climbed down to admire his work.

Word spread quickly that young Burke had been ordered to reverse the green and red lenses. The news incited Irish merchants — Mooney, Gilmartin, and O'Brien among them — to hurl stones and sundry missiles at the light until they prevailed. The Green Light on Tipperary Hill is the only light like it in the world.

Ties with the old country remained strong. Recent immigrants repaid my grandmother's hospitality with news and stories from home. Those days I listened and laughed and determined that one day I would see Ireland for myself.

The "Green Light"
Tipperary Hill
Syracuse, New York

I learned Irish history from Bill O'Dwyer, Katie's nephew, in the pubs around Thurles and Upperchurch. The man was a philosopher. No subject escaped him. On partnerships, Bill cautioned: "Never join anyone except in rosary." On life, Bill counseled: "Concern yourself with the luxuries and let the necessities take care of themselves."

In 1971, I shared a flat with Bill's sons in Dublin. Those days began with a short walk to a Trinity College dorm for a hot shower and on to a small office in Lower Abbey Street. From "half-four to half-nine," I played rugby for Railway Union or saw a play or visited the National Library in Kildare Street. After ten, I could be found in a pub somewhere on Merrion Row.

From the price of a play to the price of a pint, it was a wonderful time to be in Dublin. The musical Chieftains played in a tiny auditorium off Parnell Square; the Dubliner's were in town; O'Donoghues was the unofficial post for the Clancy Brothers and Tommy Machem; O'Dwyers hosted nightly debates pitting the communists against theologians from Trinity College; the snugs were always full.

O'Casey's great canvas was Dublin, but his characters might have come from Tipperary Hill where the Captain Boyles' and Joxer Dalys' dodged Sunday mass as the likes of Juno and Mrs. Grogan squeezed into the first pew. Where the Seumas Shields' and "Needle" Nugents' held capricious conversations with our own Jake Costello and Nibsy Ryan over the vagaries of the pluperfect past. Where Fluther Good might have admired the green light even as word came down to reverse a job well done.

In 1923, Sean O'Casey rose from obscurity to have a play, *The Shadow of a Gunman*, produced by the Abbey, followed, in 1924, by *Juno and the Paycock* and, in 1926, *The Plough and the Stars*, which incited a riot at its premier.

W.B. Yeats, the esteemed Irish poet and co-founder of the Abbey, took the stage during the melee and declared the incident to be O'Casey's apotheosis: his deification. O'Casey played to full houses which the Abbey depended upon as much as the playwright depended on the royalties. He had become world famous and counted among his acquaintances many of the most prominent literary figures of the day.

In 1928, however, Yeats and the Abbey rejected a new O'Casey play. O'Casey was devastated. The audience he had been guaranteed by the Abbey productions was gone. His financial security was gone as well. I asked my cousin Billy, a barman on Merrion Row, about O'Casey. "Sean O'Casey had different thoughts about the game," Billy said. "Yeats should have been got and done for goin' thumbs down on *The Silver Tassie* after O'Casey saved the Abbey Theatre!"

It was time for O'Casey to show his mettle and that's exactly what he did. For the next thirty-eight years, Ireland's literary lion roared! Sean O'Casey cultivated his own audience through his creative genius and magnetic personality.

Sean O'Casey and his work are a great source of inspiration to me. With a pen, O'Casey did what I strive to do with a camera: record sharp, colorful, evocative images. Our common ground is the eye, which O'Casey referred to as "the jewel of the body." And now, after twenty years in the hunt, I raise a toast to Sean O'Casey, Katie Donovan and Ireland as we celebrate a glimpse of Erin.

*B*e God, said the man

with the wide watery mouth

and the moustache drooping over it

like a weeping willow,

as he turned his head to speak

to all in general,

be God, they haven't spared any

expense to turn Dublin into

a glittherin' an' a shinin' show!

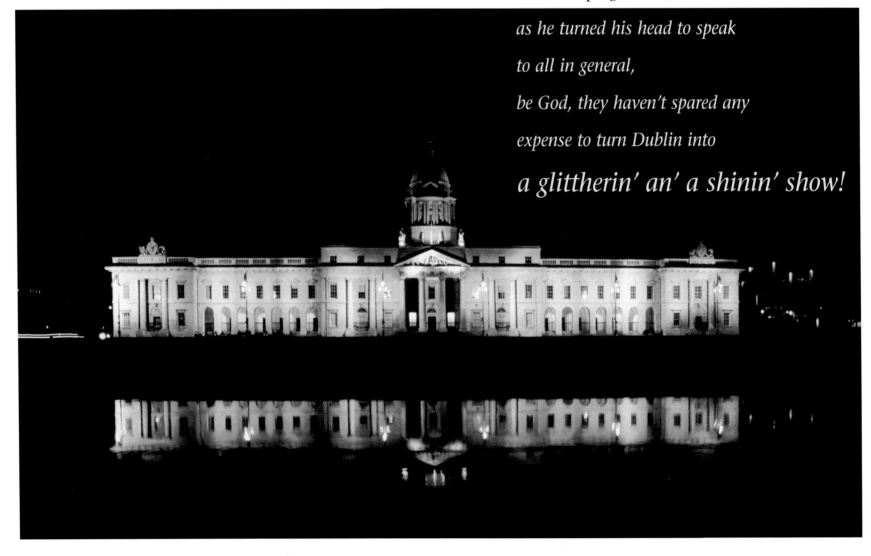

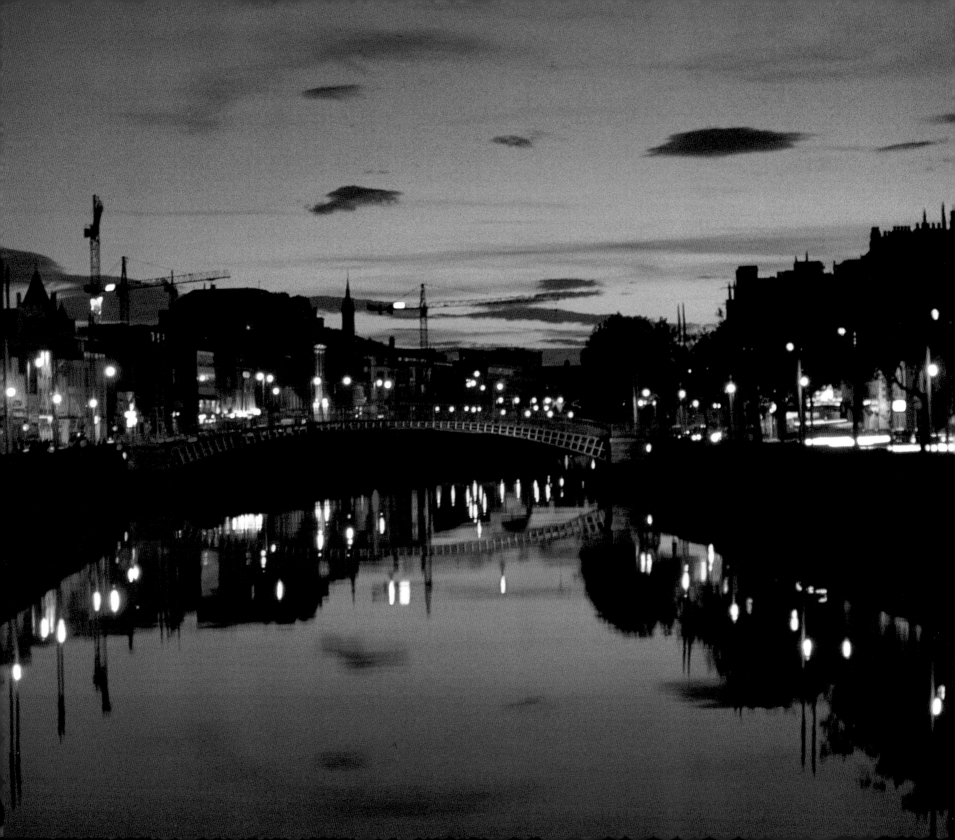

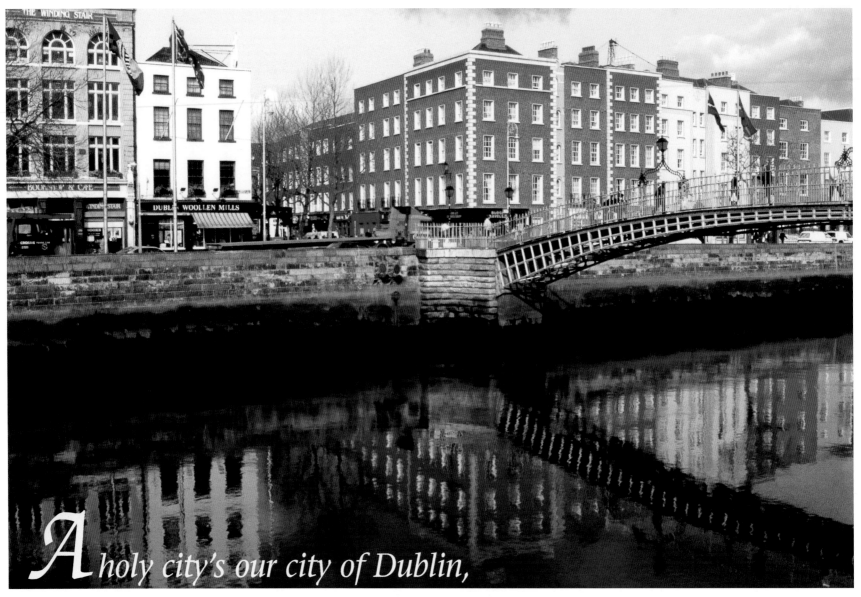

\mathcal{A} holy city's our city of Dublin,

thought Johnny; more ancient than Athens; more sacred than Rome; as holy as Zion.

From every window, if one had only eyes to see, flew a banner that was a red, brown, white,

or blue scapular, each with some holy words of the Lord, or one of His saints, embroidered across its field;

and from every pillar and every wall hung festoons of rosary beads, the precious jewels of a poor people.

All the fame of Dublin City

from the time the

first worried warriors

crossed the river at the

Ford of the Hurdles,

to the recent days

when desperate

Irishmen from corner,

from pillar and post,

sent shot after shot

into the Black and Tans,

can gather to pass by,

or stop to talk

in a corner of

an Irishman's mind.

3

*W*hat'r you doin'

here in a place like this,

me oul'-fashioned, cocky little

kidger, with your ears open to

catch any language that'll help

to knock hell outa all

decency in later life?

4

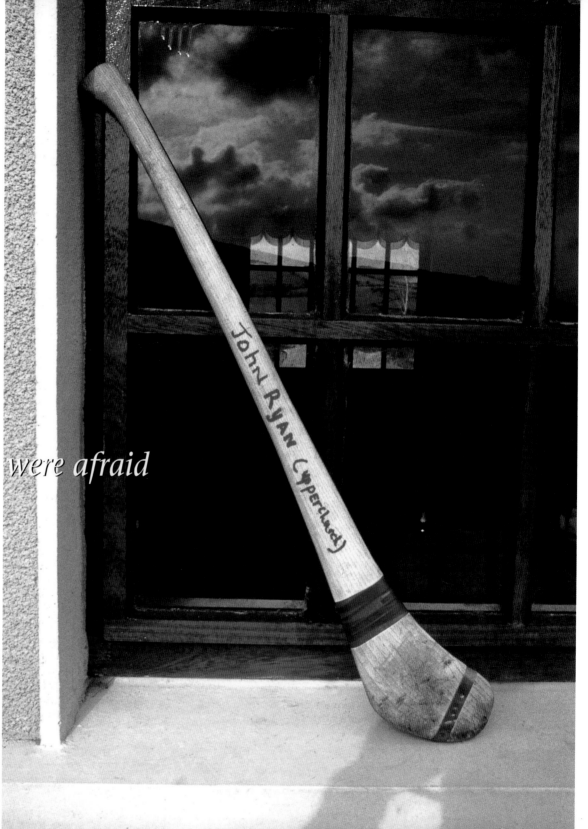

*T*he two constables *were afraid*

of the hurlers,

for no one could say,

especially a policeman,

what a hurler would do when

he had a hurley in his hand.

So they turned on the

other party, very officious

and full of the law.

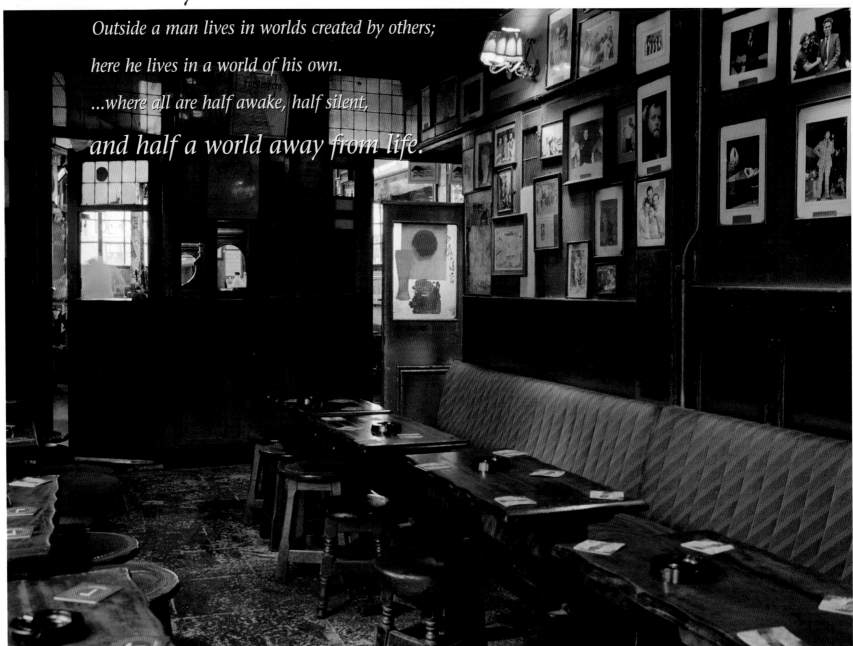

Here every man has all he wants.

Outside a man lives in worlds created by others;

here he lives in a world of his own.

...where all are half awake, half silent,

and half a world away from life.

...*a* stout-bellied,...*ruddy - faced man*

...puffing stormily at a big pipe.

A pair of small

glittering dark eyes

were trying to climb out

over the puffy lids

that half-buried them;

and a gay smile on his face...

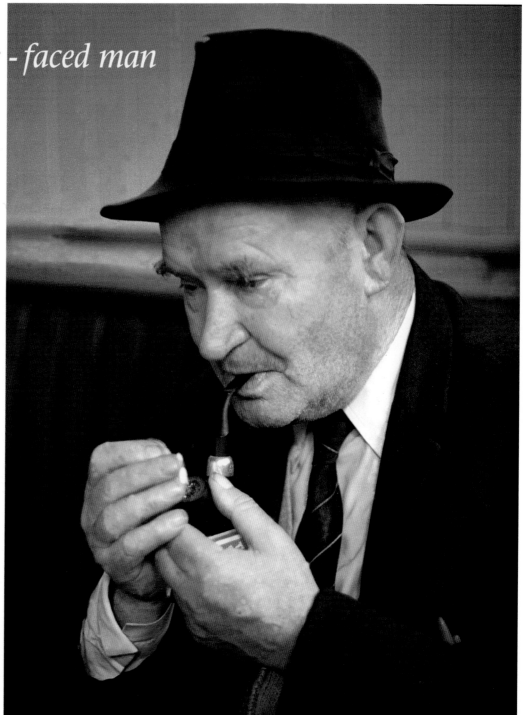

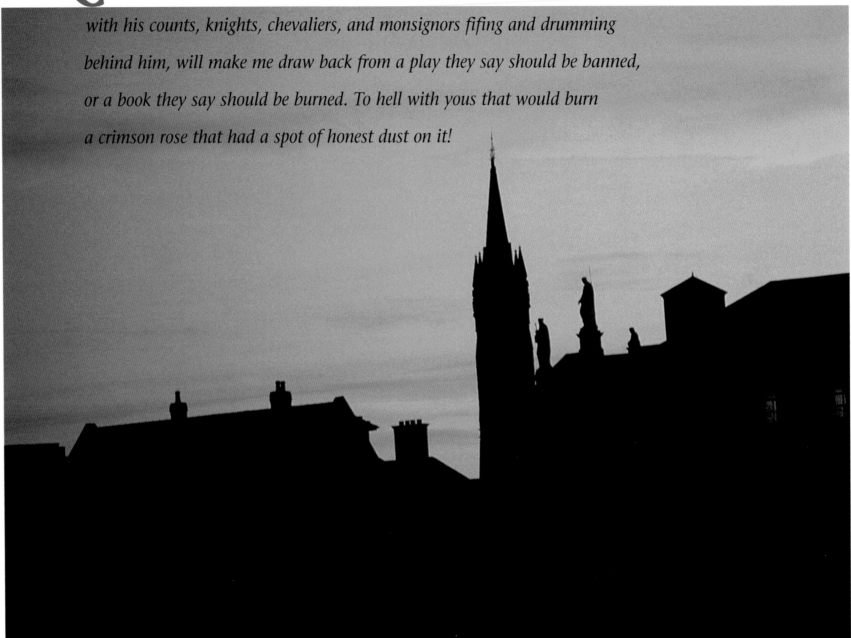

*N*o cardinal, no, nor even the Pope himself,

with his counts, knights, chevaliers, and monsignors fifing and drumming

behind him, will make me draw back from a play they say should be banned,

or a book they say should be burned. To hell with yous that would burn

a crimson rose that had a spot of honest dust on it!

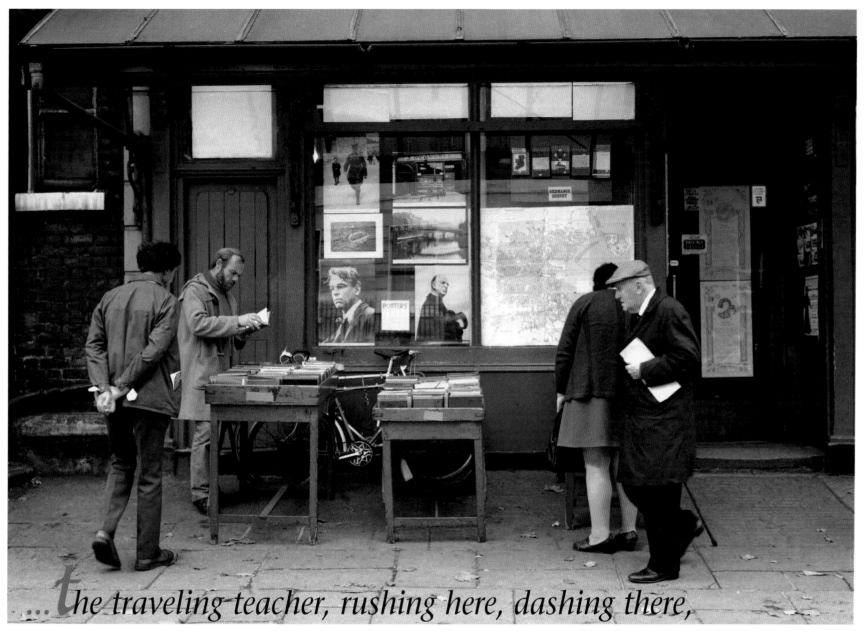

...the traveling teacher, rushing here, dashing there,

to teach a class, to help found a new branch, spreading the Irish as a tree sends forth its pollen,

seeking neither to gain a reward nor to pay a penance, but for thee, only for thee dear land,

and for thy language that it may come back to us, be brought back to us by persuasion or by force...

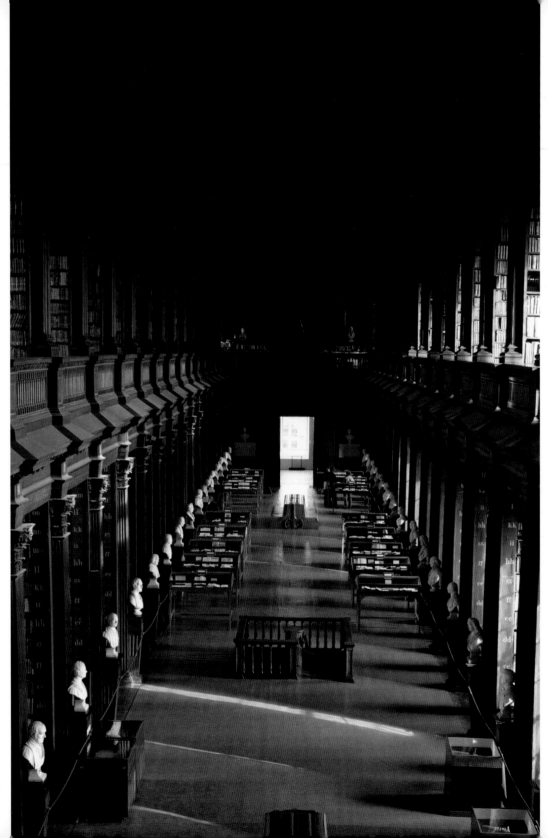

*I*gnorance found a god

everywhere and in everything,

and ordered life according

to their imagined whims.

Knowledge had been

hunting the earth and

scouring the heavens

for but one God,

but has found none.

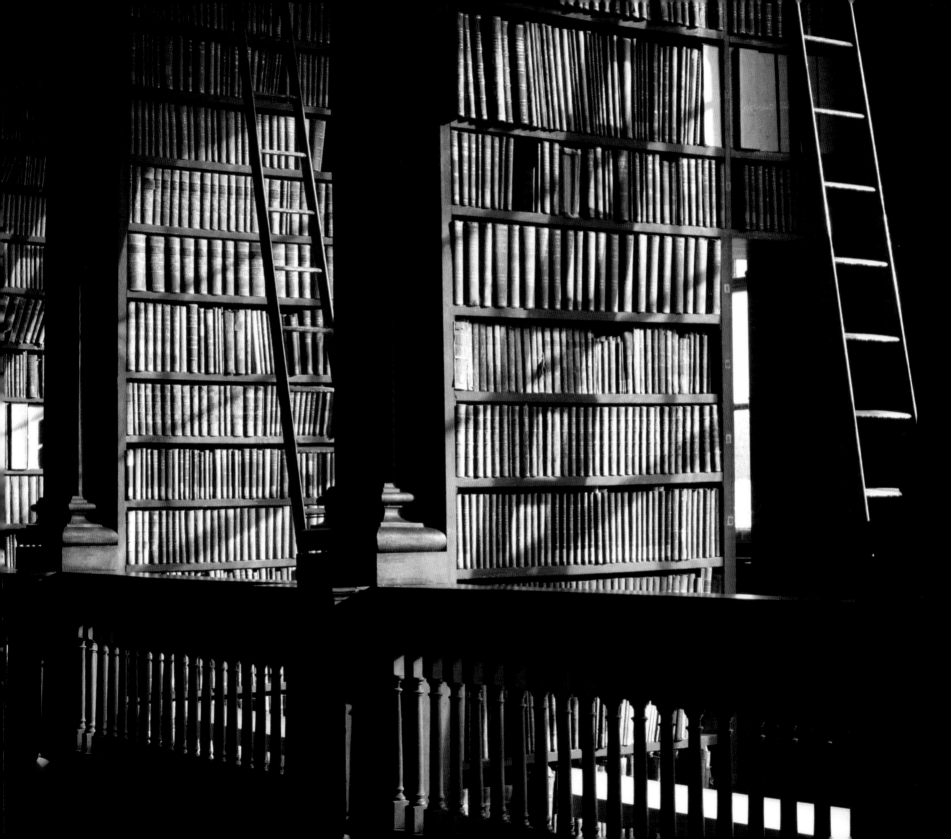

...*Our* members read the paper,

now, not for guidance or for inspiration,

but merely in a sense of duty.

Hobson's articles are nothing more

than hundreds of dead thoughts

on thousands of cold,

leaden slabs of words...

Shaw, Shaw!

Sean would say petulantly; you're forever shouting that fellow's name in our ears. Who is he, anyway?

— The cleverest Irishman the world knows, Sean. A wit of wonder. A godsend to men who try to think, who's creating a new world out of a new thought. Read "John Bull's Other Island," and the Ireland you think you know and love will vanish before your eyes.

W
hat was he thinking of as he stood there,

grim and scornful? Tormenting himself with the fading vision of a most lovely lady

whose golden hair was hanging down her back, so full of fire that a tress of it would

give light to a group threshing corn in a black barn on a dark night.

14

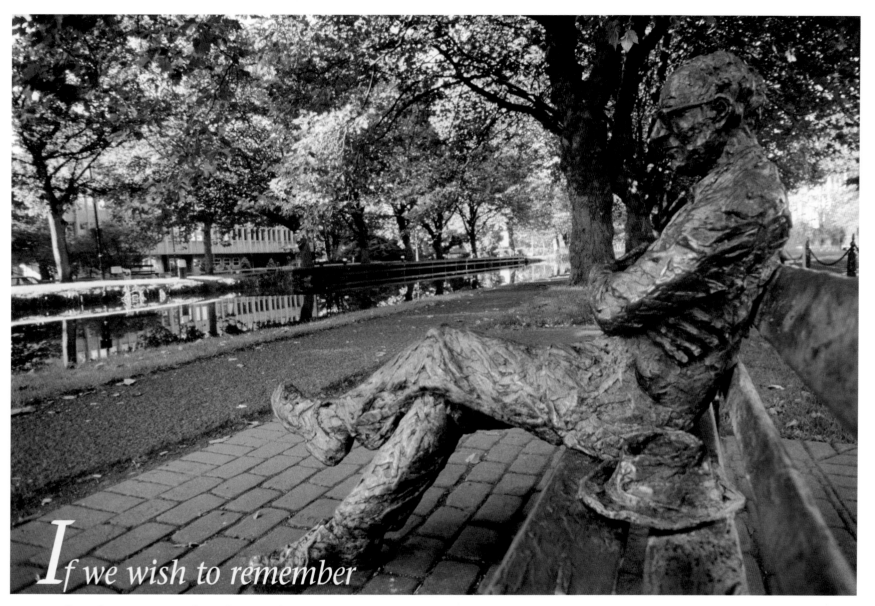

If *we wish to remember*

loved ones gone, then let us place the sculptured stone, the green bush,

the climbing rose, apple-bloom, and cherry-blossom in public places

where the sun shines, children play, and the living pass to and fro.

Only the thoughts of the living can give the mortal immortality.

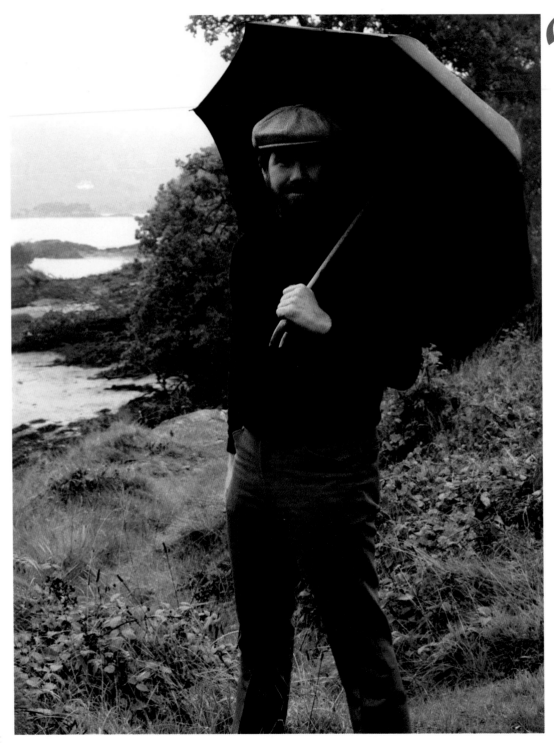

*W*hen it was done,

maybe, he'd send it to Shaw,

and ask him to

write a preface praising it.

He wouldn't part

with this new work

for less than twenty-five pounds.

With cunning, that would

keep him going for a year,

and give him time to think

of something else to do.

I'm looking for a place near the sea;

I'd like the place that you might say was me cradle,

to be me grave as well.

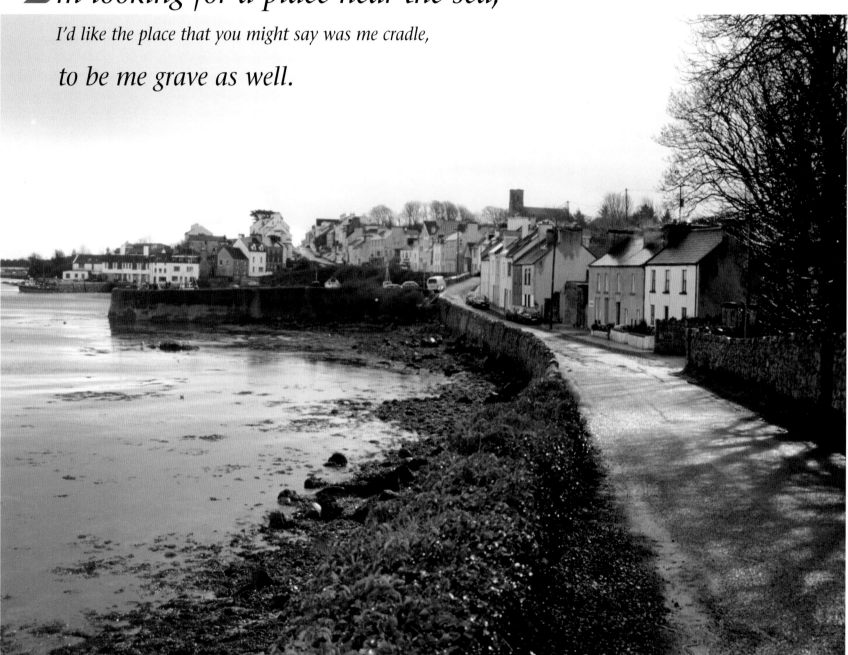

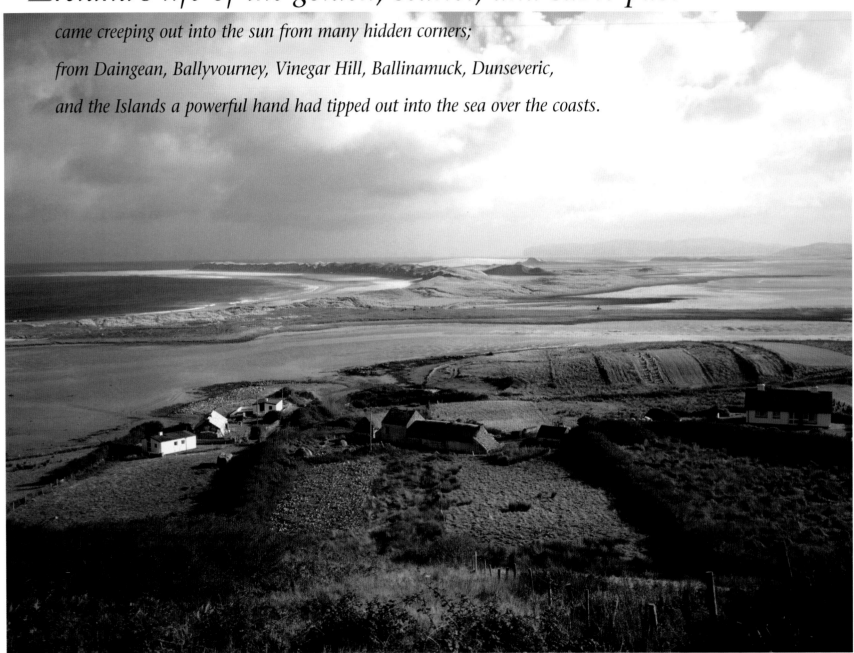

*I*reland's life of the golden, scarlet, and sable past

came creeping out into the sun from many hidden corners;

from Daingean, Ballyvourney, Vinegar Hill, Ballinamuck, Dunseveric,

and the Islands a powerful hand had tipped out into the sea over the coasts.

...*t*reasures

that couldn't be left to the chance of

the wind or the rain.

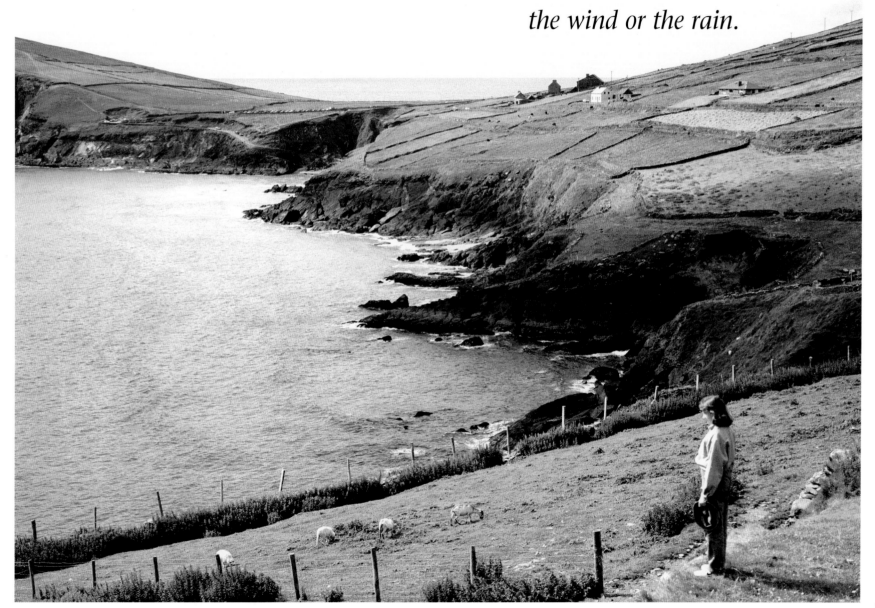

*S*trange how the glimmer of little things

reminded you of bigger things hid in the

heavily-veiled mystery of the past!

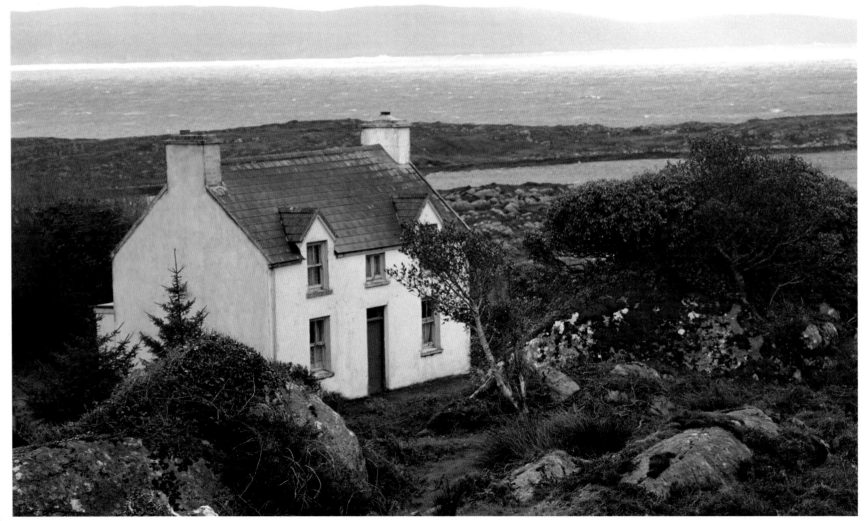

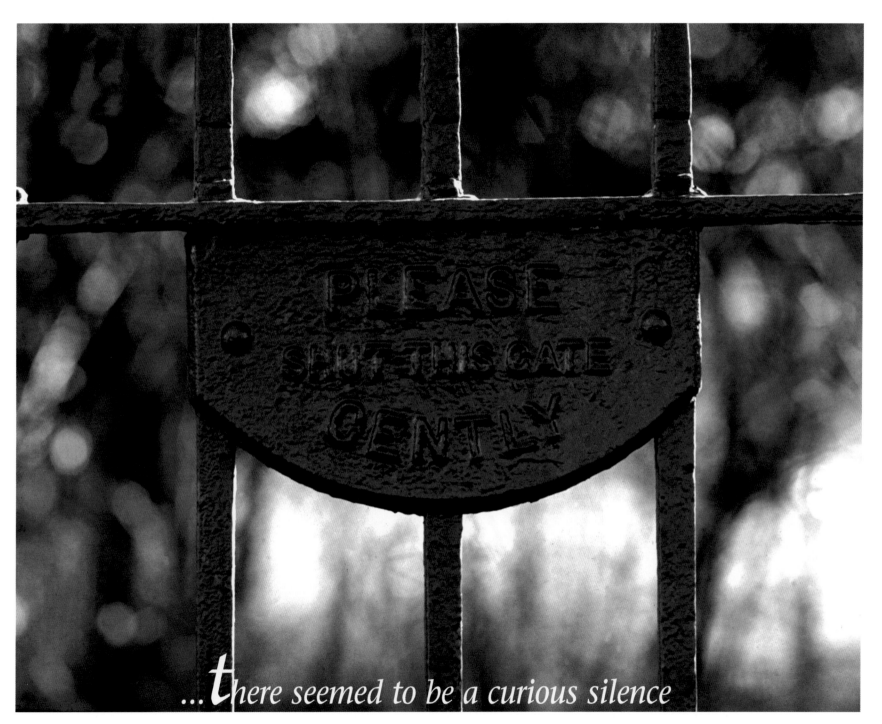

...*there seemed to be a curious silence*

in the house; a silence that flooded in and flooded out whenever a door was opened...

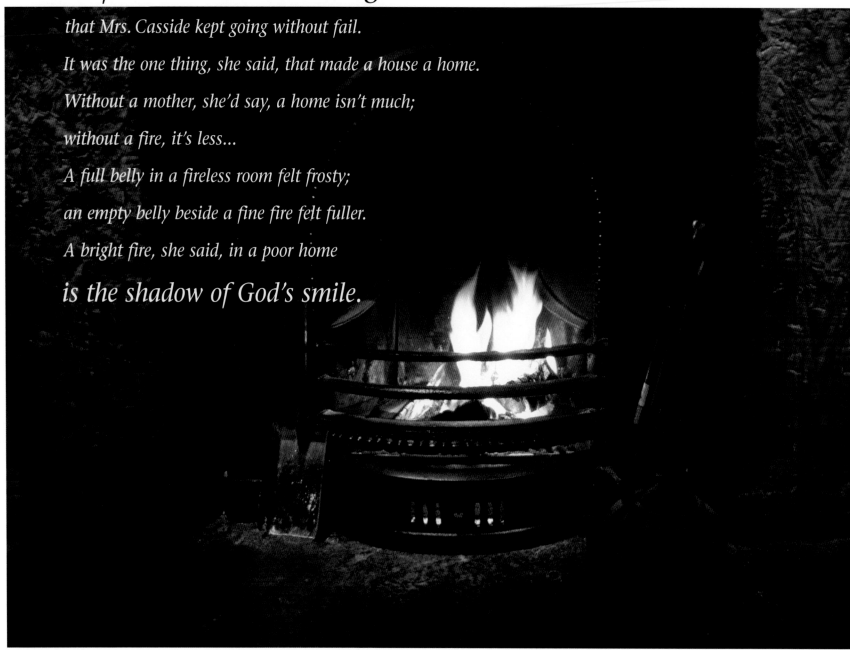

The fire was the one thing

that Mrs. Casside kept going without fail.

It was the one thing, she said, that made a house a home.

Without a mother, she'd say, a home isn't much;

without a fire, it's less...

A full belly in a fireless room felt frosty;

an empty belly beside a fine fire felt fuller.

A bright fire, she said, in a poor home

is the shadow of God's smile.

She found it almost impossible

to reason out a question, and smothered the reasonable answer
of another with a squeal. She never seemed to be able to make
any golden or silver thing out of the ore of experience.
She tried verses, and failed;
she tried painting, and couldn't do any better;
and yet she never reached the rank of failure...

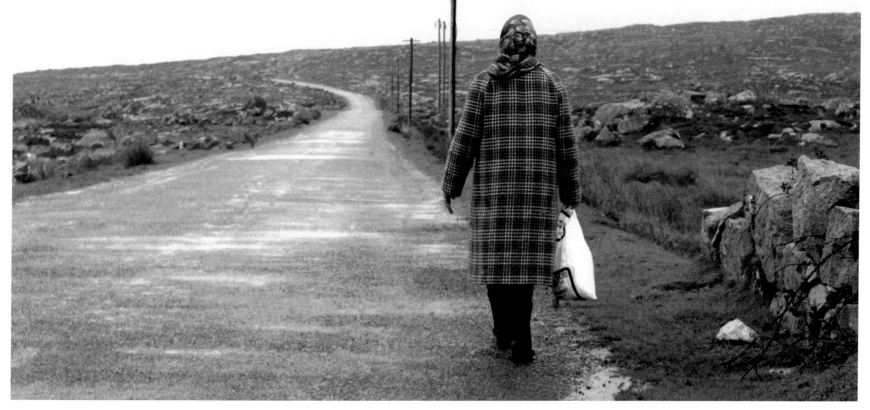

*C*urse o' Jasus on all landlords!

Sean said to himself;

and especially on this one who put me into this predicament!

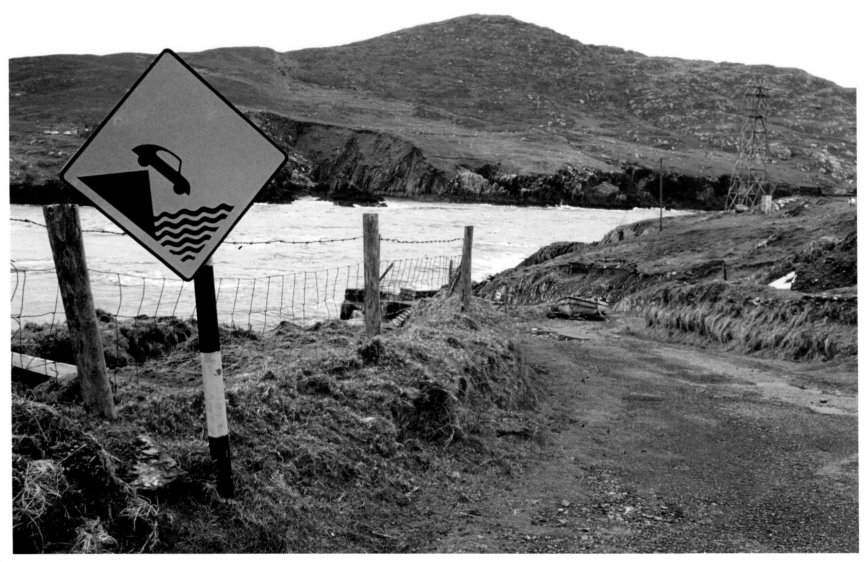

*A*ll in favor say Ay,

said the Chairman sleepily,

an hurry up,

for I've got to go to bed.

— Before we move to denial,

said Sean, let's know

what the man has said.

25

...*he cursed himself*

that he couldn't afford to spend a month, a fortnight,

or even a week in a summer school at peace in an Irish-speaking district...

there were few of them could speak as well and as rapidly as he;

and none of them with such a fire of eloquence.

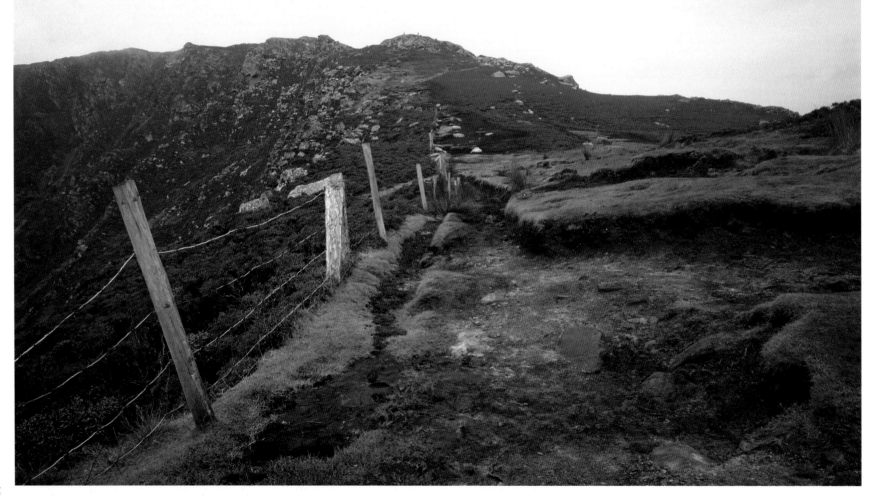

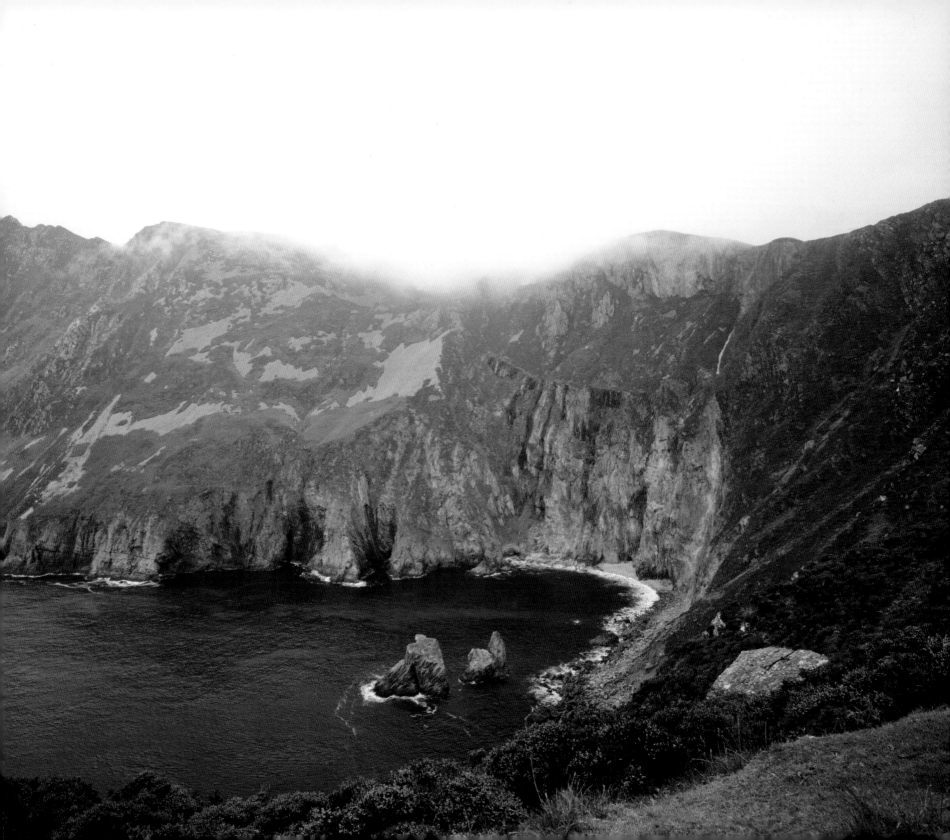

He slid over the stone wall

bordering the railway, and wandered to a grassy bank

where demure dog-daisies were jostled by flaunting

poppies, scarlet and gay, looking like gaudy whores

invading the home of quaker girls.

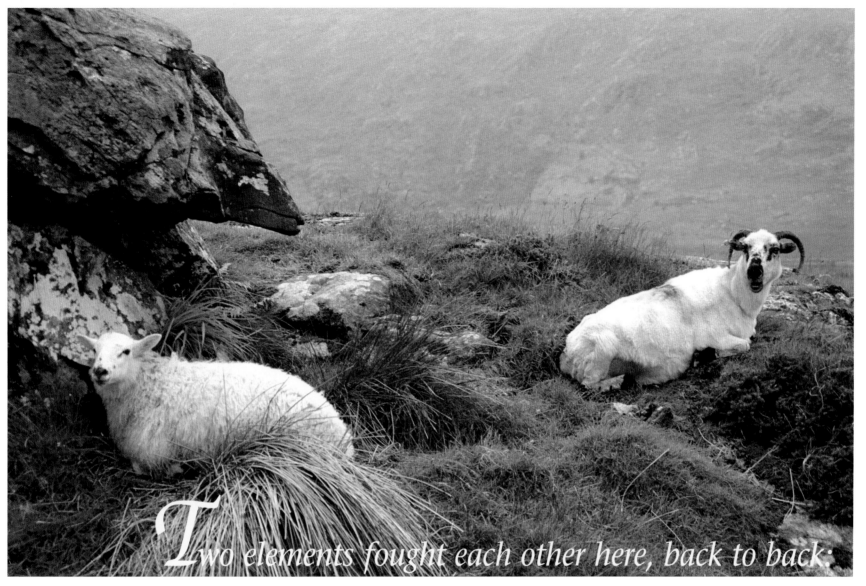

Two elements fought each other here, back to back:

a dream without efficiency, and efficiency without a dream;

but with this tense difference:

that from the dream efficiency could grow,

but from efficiency no dream could ever come.

*A*nd in all the shouting
and the tumult and the misery around,

he heard the roll of new drums,

the blowing of new bugles,

and the sound of

millions of men marching.

There he was battling for the last few minutes of life...

though he didn't know it then,

battling for the life of

Ireland and Essential Irish

in the New University,

his funds near gone,

and poverty asking him

how he was feeling.

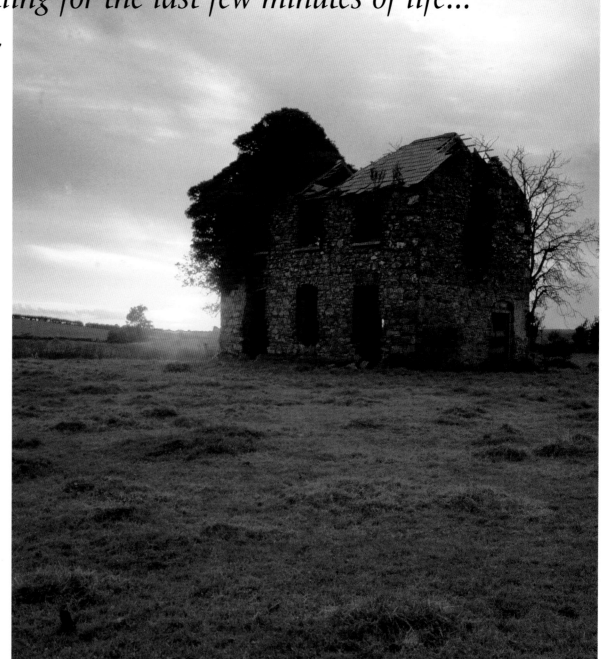

...there was no way out,

so they fought by day, and rested by night for a lunar month,

till Cuchullain, full of wounds and mad with anger, could stick it no longer

and killed Ferdiah without any hindrance; then came the caoining skirl of

the pipes, and the sad rolling of the drum, mingling with the hues of red,

brown, green, and purple kilts and shawls, ending a scene of a song that

in colour, form, dignity of movement, and vigour of speech made the

loveliest things that had ever patterned the green sward of the

playing-field of Jones's Road, or any other field the world over...

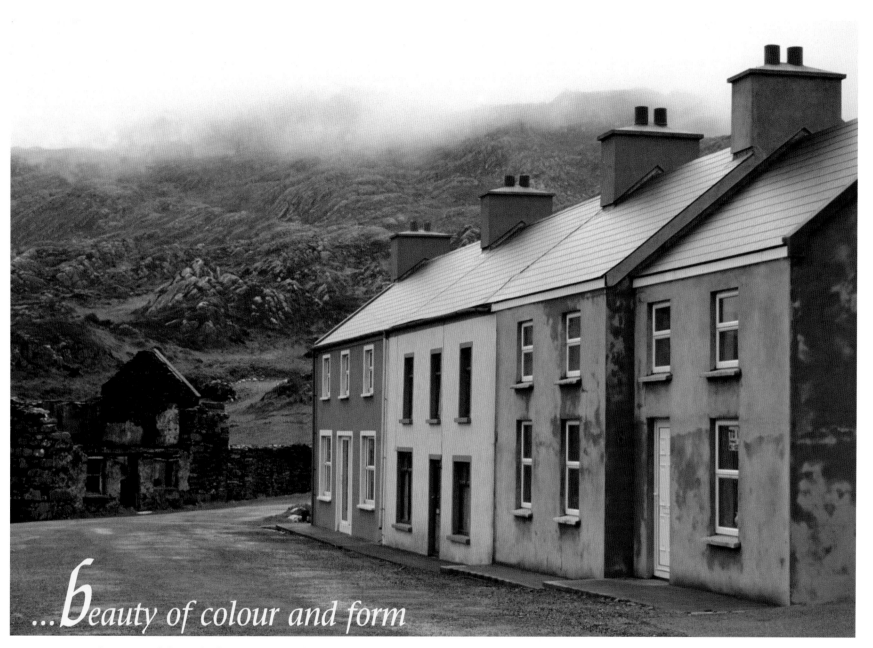

...*beauty of colour and form*

above and beside him came closer; came to his hand;

and he began to build a house of vision with them,

a house not made with hands, eternal in his imagination...

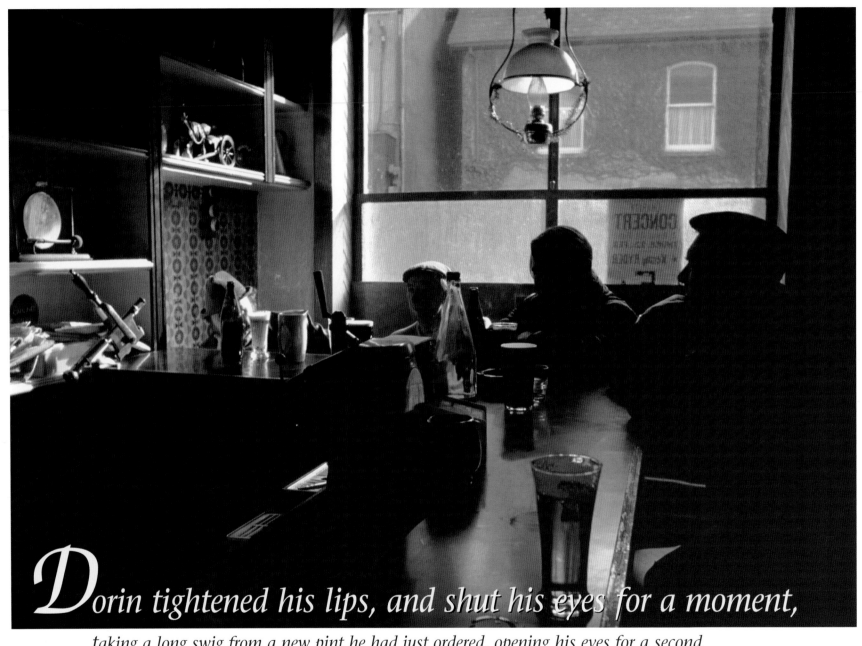

Dorin tightened his lips, and shut his eyes for a moment,

taking a long swig from a new pint he had just ordered, opening his eyes for a second

to put the tumbler back on the counter, and then closing them again,

so that the darkness might be an aid to deeper thought.

34

I don't profess to know much about poetry.

I don't know much about

the pearly glint of the morning dew,

or the damask sweetness

of the rare wild rose,

or the subtle greeness

of the serpent's eye,

but I think

a poet's claim to greatness

depends upon his power

to put passion

in the common people.

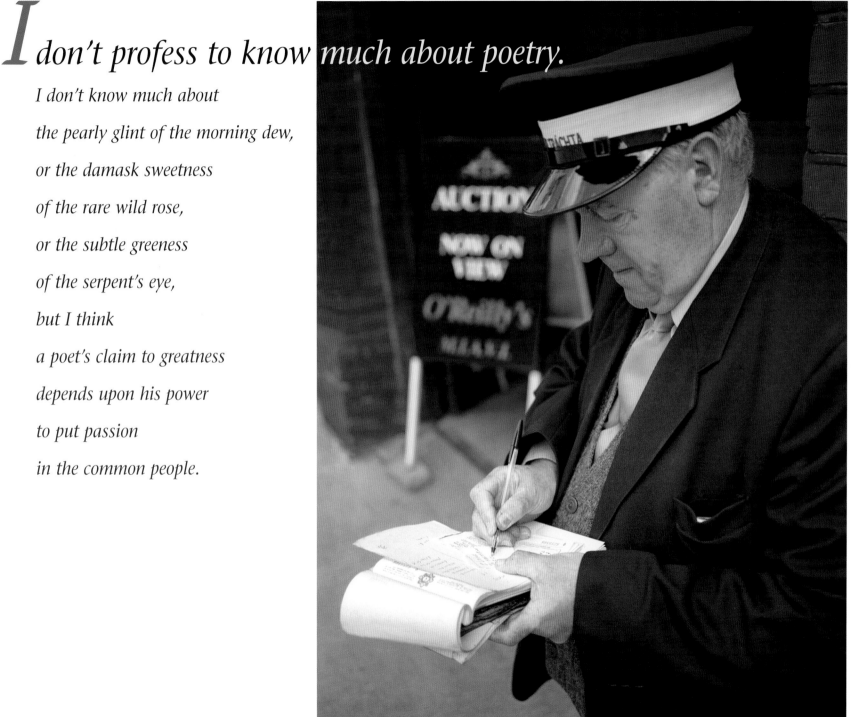

35

I have me times of fear

an' darkness

till I'm lit up with th' spirit,

an' then I live where few can rise to;

an' when I'm hoarse singin',

I lie down in th' corner

of some dark sthreet,

far from th' walled-in woe of a room;

an tell me who has a betther bedspread

than the uncomplainin' sky

holdin' on to crowds of drunken stars

dancin' mad for my diversion

as long as I elect

to keep me eyes wide open.

*H*e hasn't any eye for colour, thought Sean. Here are the golden trumpets of musk sounding at his very ear; a carillon of purple fuchsia bells pealing pensively, and he can hear neither; and there was the rose window of a scarlet geranium behind them, and his eyes were too clouded with worldly things to see it. This man couldn't understand that when Sean's mother reverently touched the blossoms with her gnarled finger, God Himself was admiring the loveliness He had made.

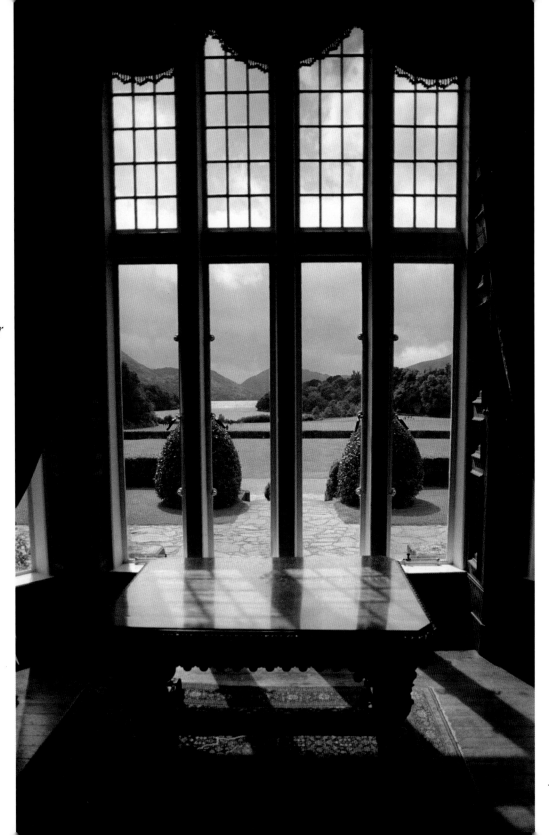

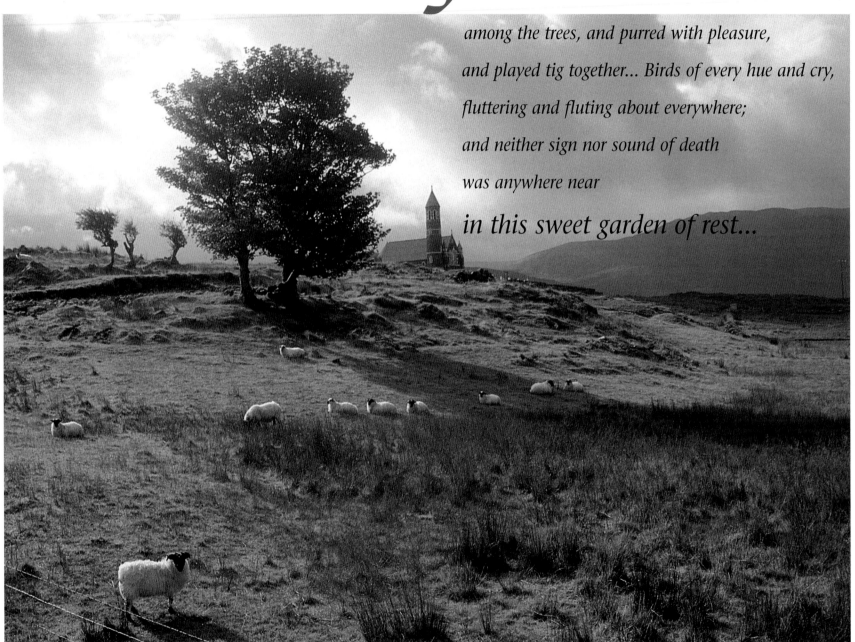

Gentle animals padded about

among the trees, and purred with pleasure,

and played tig together... Birds of every hue and cry,

fluttering and fluting about everywhere;

and neither sign nor sound of death

was anywhere near

in this sweet garden of rest...

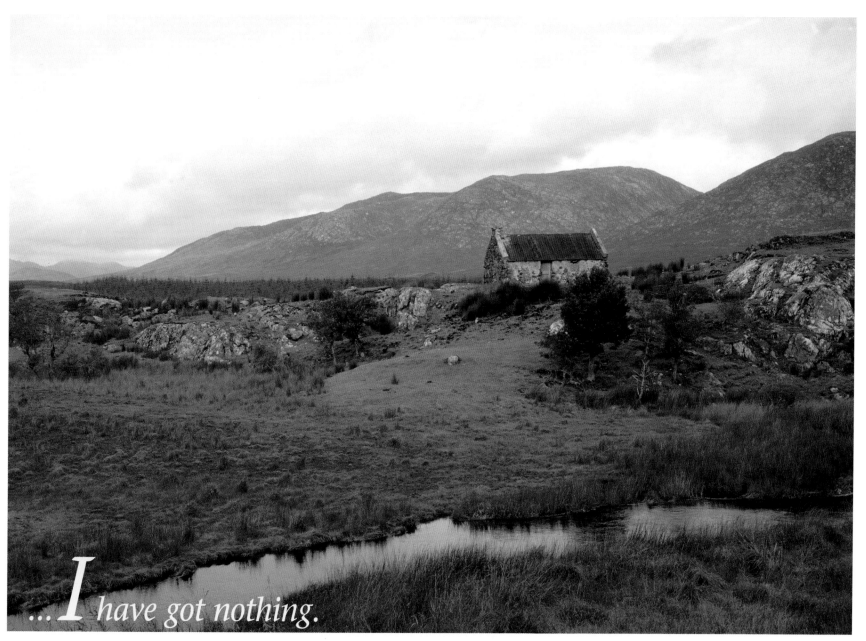

...*I have got nothing.*

Nor do I want anything; but I am determined to hold on to what is mine own;

my way of thinking, and freedom to give it utterance.

Otherwise the little life I have would cease to be life at all.

39

*I*t was indeed easy

for some who had inherited wealth to achieve a rapturous poverty;

not so easy for those who had inherited poverty to show it with a fine form and bright colours.

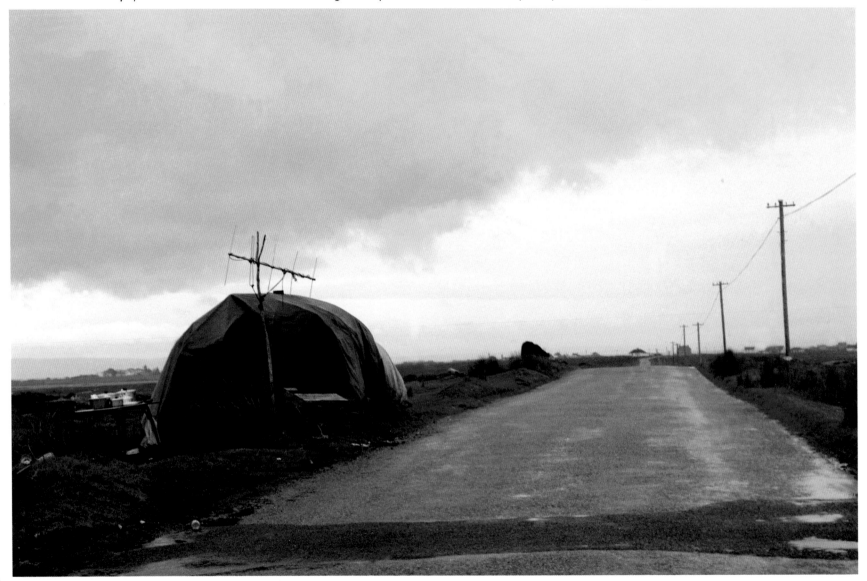

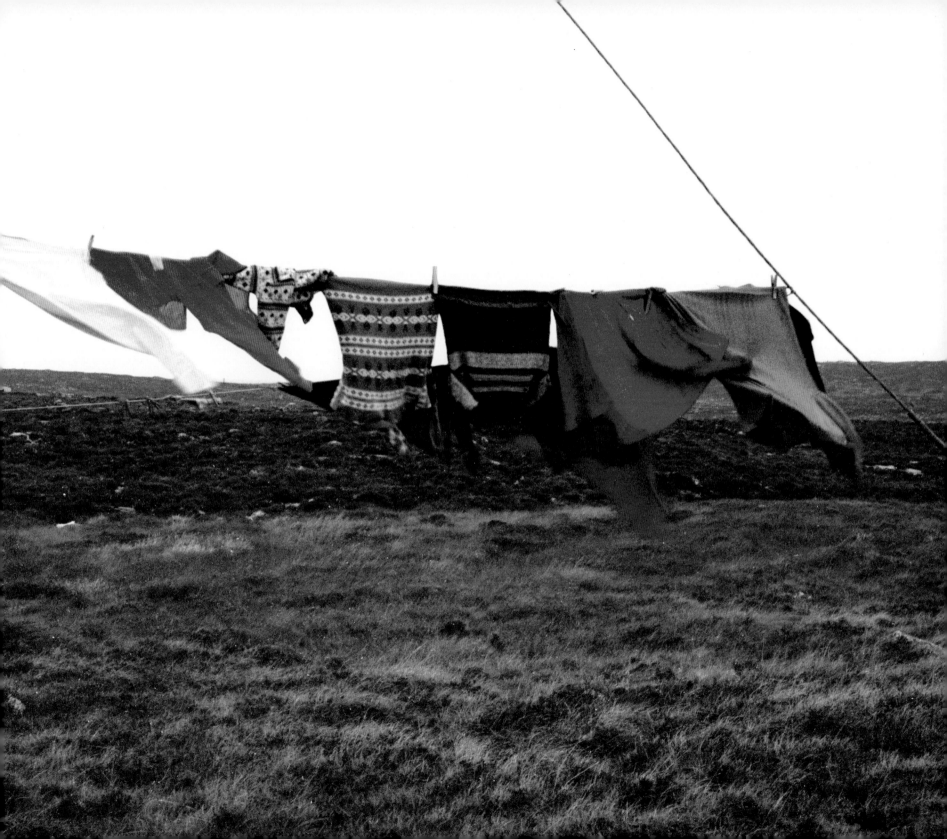

*E*ven when the rooms

were bare of fire

and scant of food,

he sang...

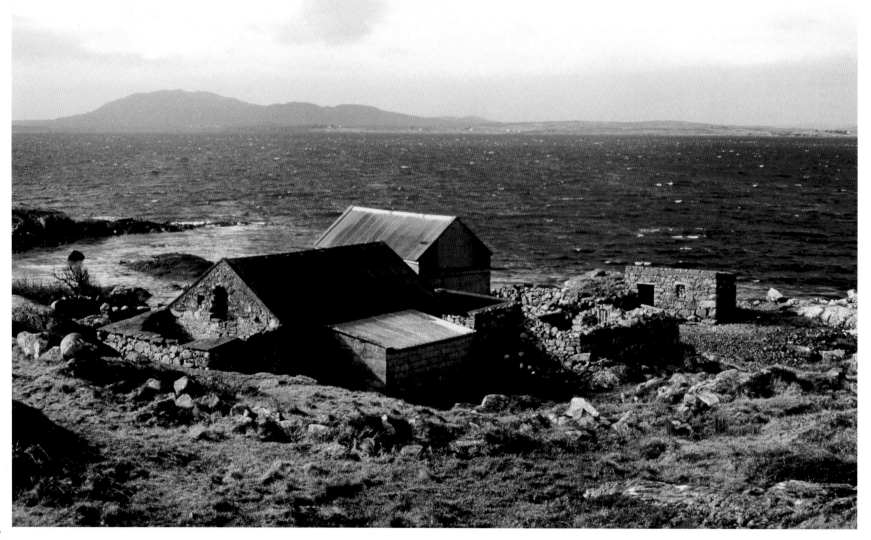

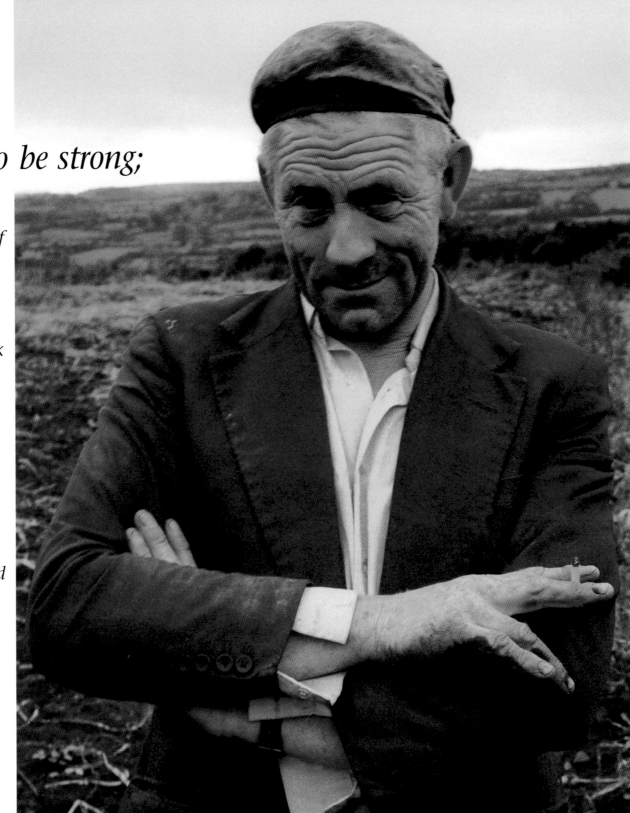

*H*e resolved to be strong;

to stand out among
many; to quit himself
like a man;
he wouldn't give
even a backward look
at the withering
things that lived
by currying favour
with stronger
things;
no busy moving hand
to the hat for him.

43

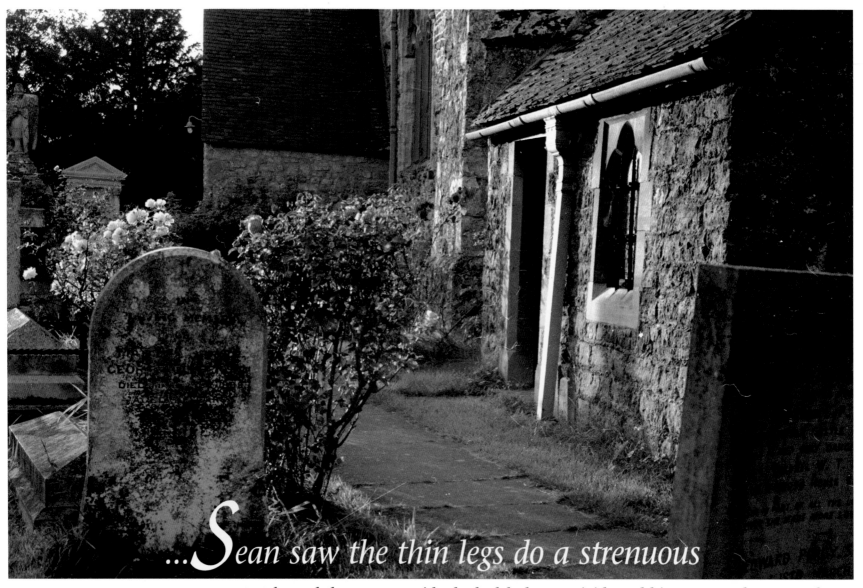

...*Sean saw the thin legs do a strenuous*

stretch, and the arms outside the bedclothes go rigid; and his ears caught a sound

like unto the sudden snapping of a sensitive cord strained too tight,

so he knew that Tom's heart-strings had given way,

and that he was now to lie still forever.

44

*A*ll that man can do

is to make what man's life may be; to make what man's life must be;

to ensure that life coming on to the stage when the curtain rises

shall play its part out till the curtain falls.

That is as much as we know; that is as far as we can go...

The rest, if there be a God, must be left in His cool, accommodating hands.

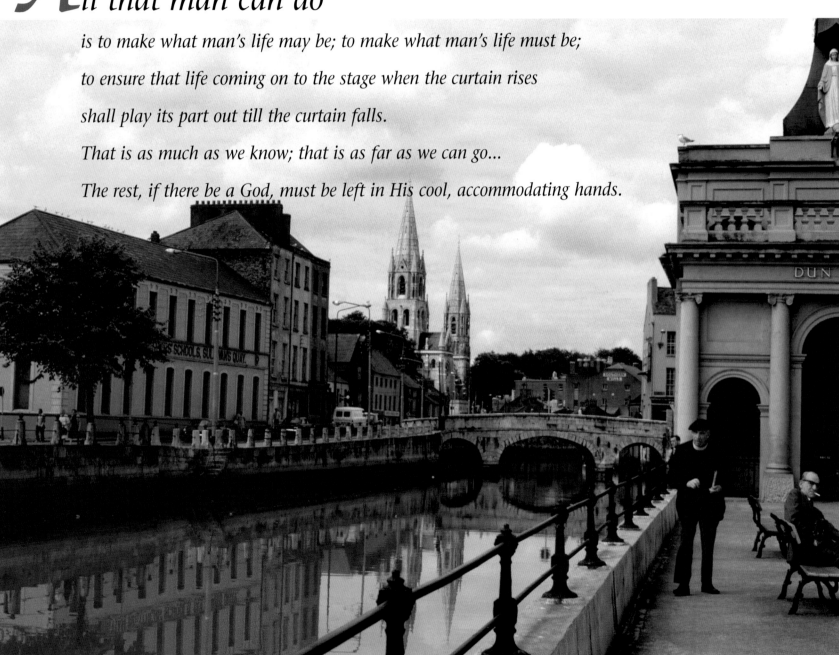

Coloured peace was here;

a gay peace;

a merry stillness,

undisturbed but for the ratchet-like call of the corncrake.

Oh, blessed peace!

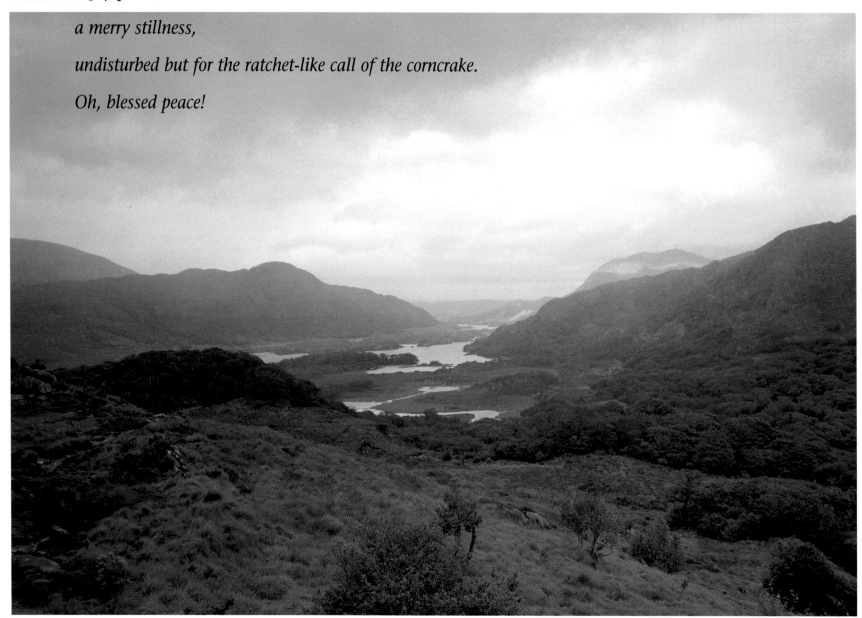

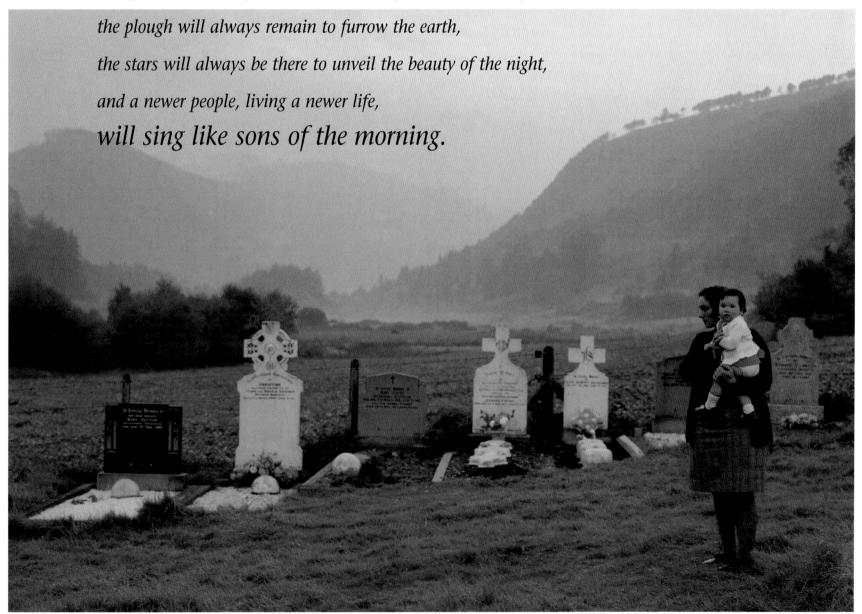

*W*hatever may happen to me,

though I should mingle with the dust, or fall to ashes in a flame,

the plough will always remain to furrow the earth,

the stars will always be there to unveil the beauty of the night,

and a newer people, living a newer life,

will sing like sons of the morning.

*O*nly ghosts of things and men

were here; nor in the sky above was any balm of blue,

or fleecy solace of a drifting cloud,

nothing but vacancy reaches to where

God had gone from.

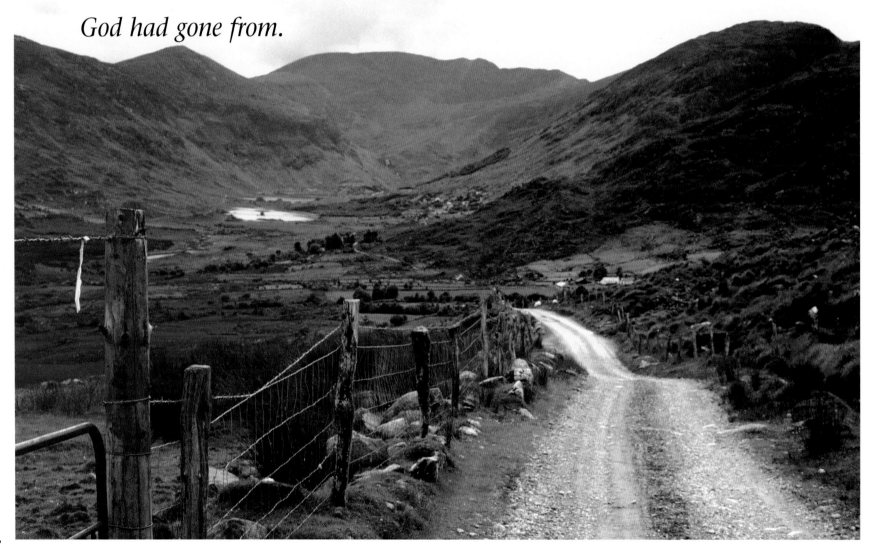

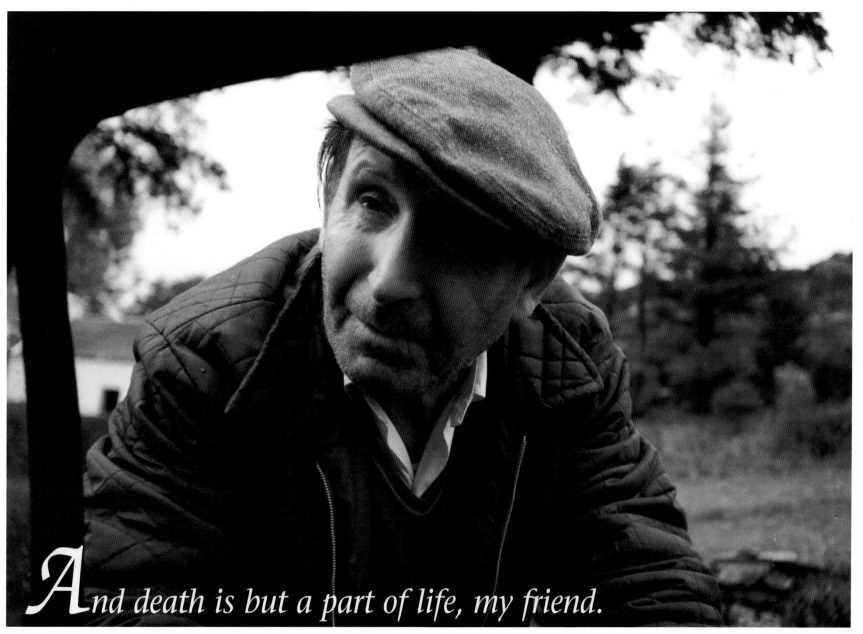

And death is but a part of life, my friend.

Dying, we shall not feel lonely, for the great cloud of witnesses who die will all be young.

If death be the end, then there is nothing; if it be but a passage from one place to another,

then we shall mingle with a great, gay crowd!

49

A magic shadow-show,

played in a box whose candle is the sun,

round which we phantom figures come and go.

But Ireland was rather more of a kaleidoscope

than a shadow-show: always reshaping itself

into a different pattern.

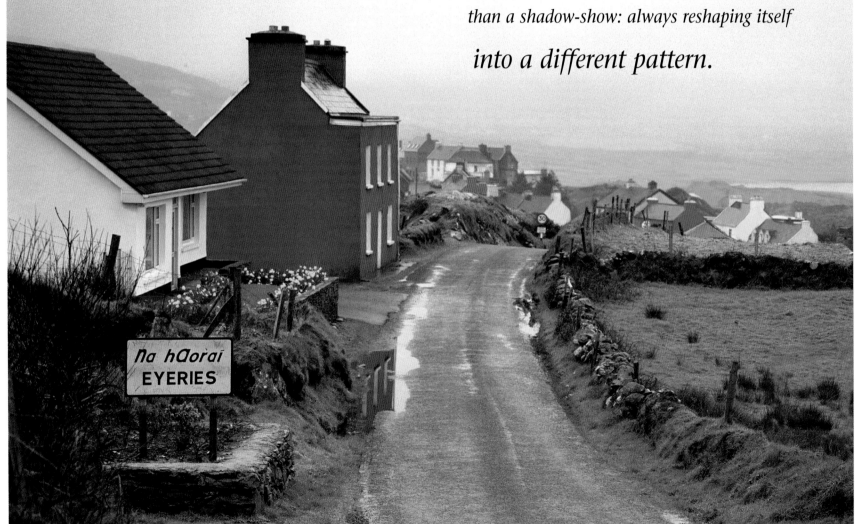

Na hAoraí
EYERIES

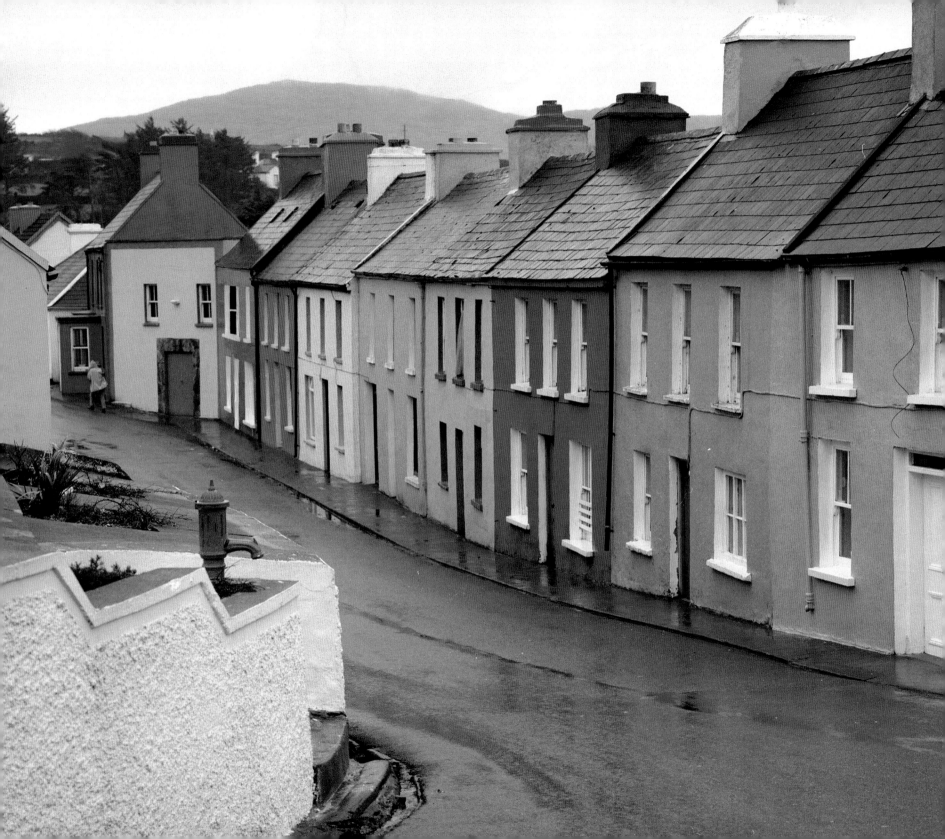

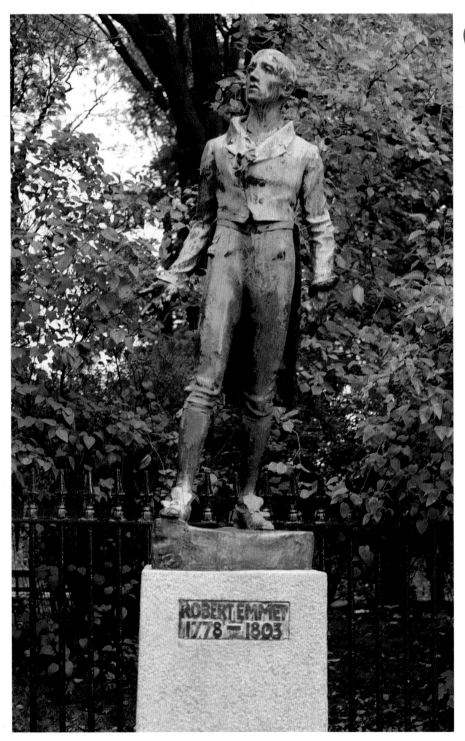

Euchan calls me a dreamer.

I thank him for the word.

He seems to think the dreamer who lives

in the inspiration of the past is a fool.

...The dreamers were and are

the salt of all nations.

Ruskin was a dreamer;

so was Burns,

the "greatest of Scots—perhaps";

so was Robert Emmet...

The shop was crowded,

full of white-coated counter-jumpers

handin' out tea an' sugar an'

margarine as swift as hands

could lay hold on them;

with men in brown overalls

trotting along pushing mountains

of tea an' sugar in packages

on little throlleys,

moving silently and cunningly

through the crowded shop,

to fill the vacancies on the shelves.

53

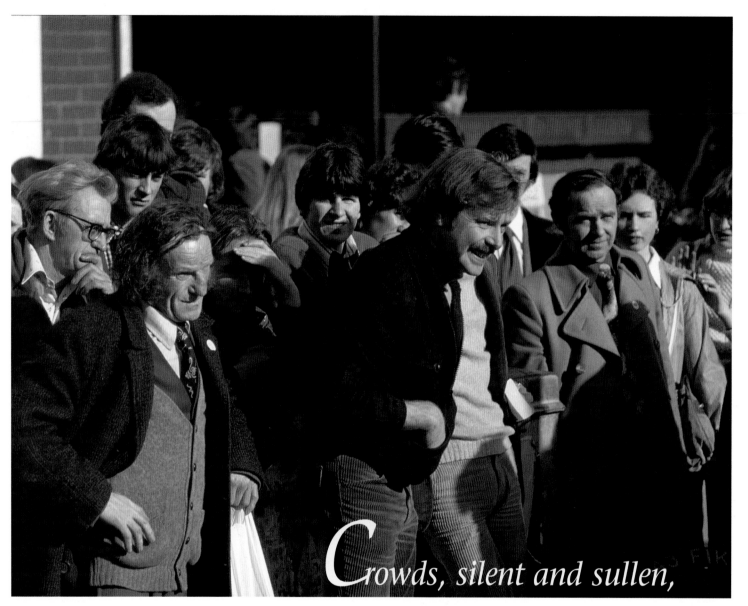

Crowds, silent and sullen,

watch them go by at the street corners, and stare at white faces

pressed against the tiny grating at the back of the van,

striving for a last glimpse of Erin ere they walk the decks of the ship

that will carry them to the prisons of England.

*B*ut Cathleen, the daughter of Houlihan,

walks firm now, a flush on her haughty cheek. She hears the murmur in the people's hearts.

Her lovers are gathering around her, for things are changed, changed utterly:

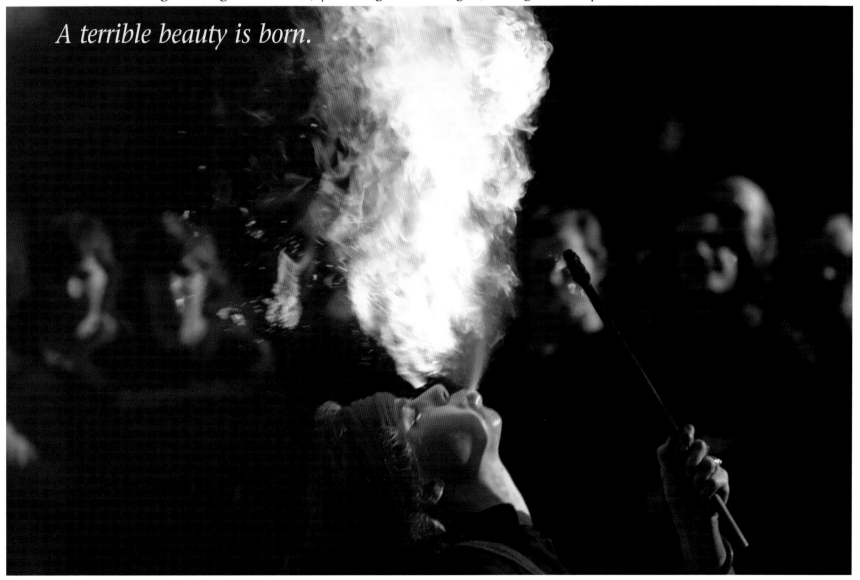

A terrible beauty is born.

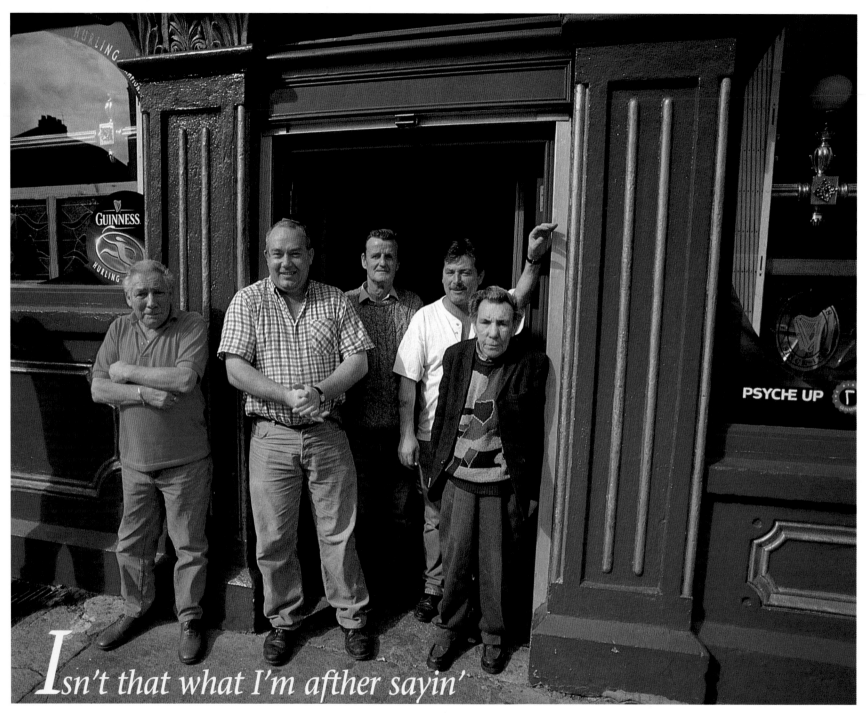

*I*sn't that what I'm afther sayin'

in plain words that would fall safely into anny ears but your own?

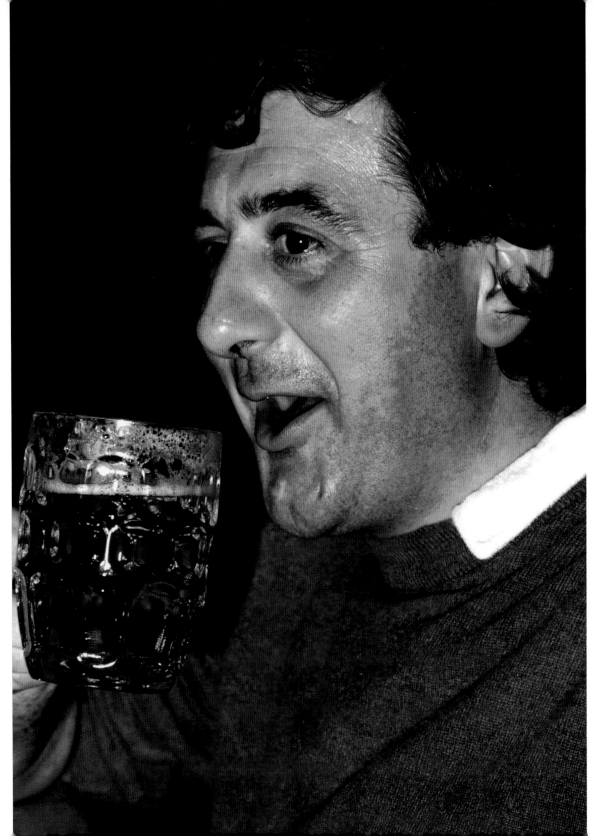

...Life is all a matter

of the "stickin' together

of millions of atoms

of sodium, carbon,

potassium o' iodide,

etcetera, that accordin'

to the way they're mixed

make a flower, a fish,

a star that you see

shinin' in the sky,

or a man with a

big brain like me

or a man with a

little brain like you!"

57

Someone in trouble,

someone in sorrow, a fight between neighbours,

a coffin carried from a house, were things that coloured their lives

and shook down fiery blossoms where they walked.

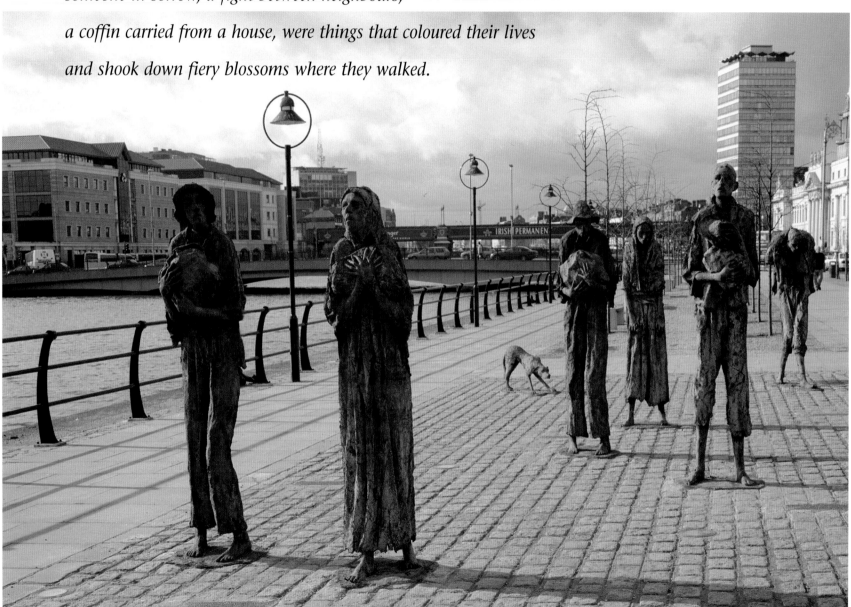

Who would be the first

to make an army out of these active and diligent dry bones?

Who the first to breathe into them

a breath from the flame of

endeavor and strife and defiance?

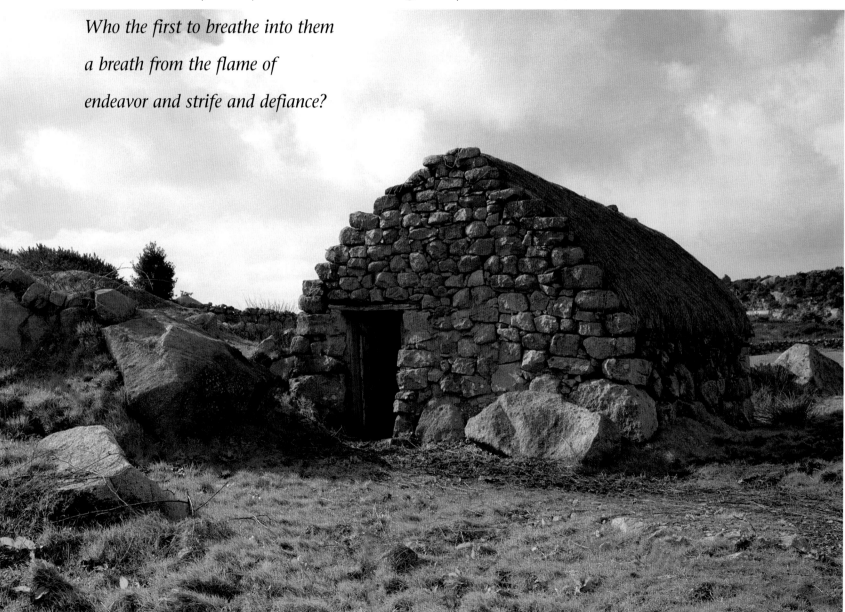

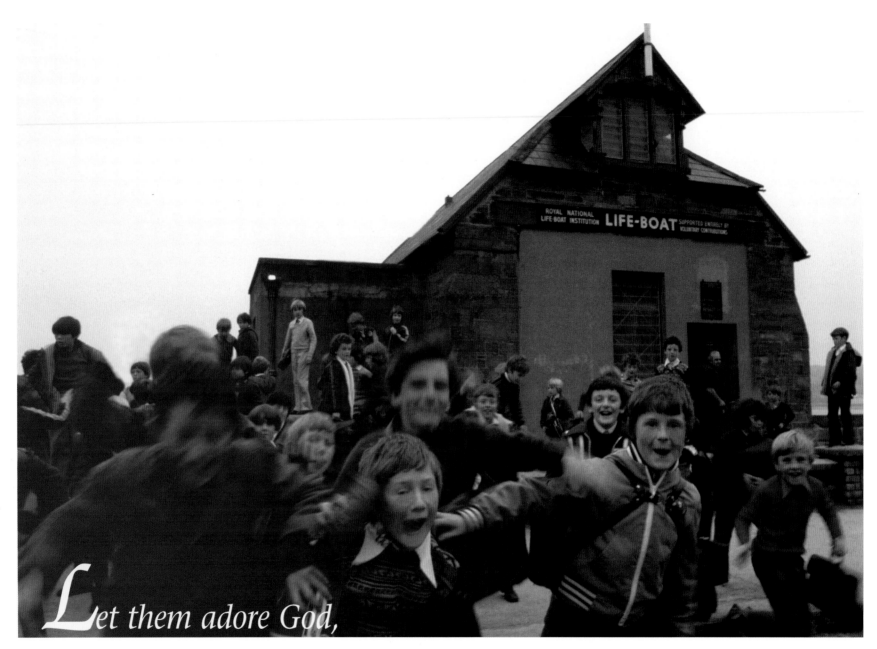

Let them adore God,

not in hypocritical hymn, tiresome prayer, and mind-torturing catechism,

but in the fullness of skipping, a hop, step, and a lep; the rage of joy in a flying coloured ball,

without a care in the world, bar their own young fears and disappointments.

𝒜 pity death pulled Pearse

away from his school...

He hated the system that kept colour and life

far from the child, content to stuff a delicate mind

with a mass of fact and information.

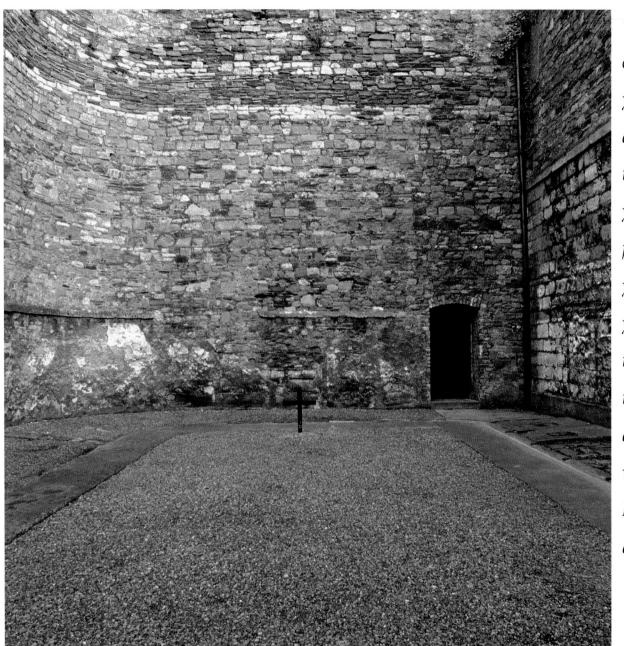

Ah! Patrick Pearse,

when over the hard,

cold flags of a barrack square

you took your last stroll

and wandered to where

the rifles pointed to your breast,

you never even paused,

for that was what you guessed

you'd come to;

you came close to them;

the stupid bullets tore a way

through your quiet breast,

and your fall forward to death

was but a bow to your enemies.

Peace be with you,

and with your comrades too.

A city of cells.

A place where silence is a piercing wail;

where discipline is an urgent order from Heaven;

where a word of goodwill is as far away

as the right hand of God;

where the wildest wind never blows

a withered leaf over the wall;

where a black sky is as kind as a blue sky;

where a hand-clasp would be low treason;

where a warder's vanished frown

creates a carnival;

where there's a place for everything,

and everything in its improper place;

where a haphazard song can never be sung;

where the bread of life is always stale;

where God is worshipped warily;

and where loneliness is a frightened, hunted thing.

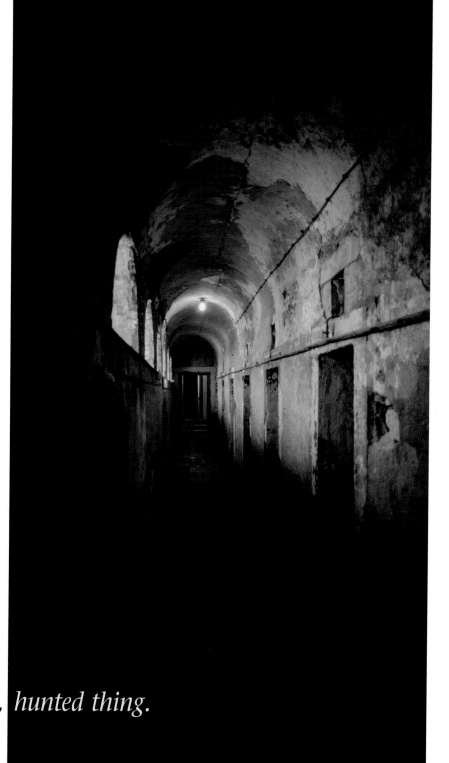

I only know

it [death] means the loss of many things;

the moving patterns of flying birds;

the stroll through crowded streets,

crudely strewn about, that the moon regenerates

into silvered haunts of meditative men;

the musical will of waves racing towards us,

or slowly bidding us farewell;

the wild flowers tossing themselves

in the field and into the hedgerow;

the sober ecstacy, or jewelled laugh,

of children playing;

the rivers rowdy rush or

graceful gliding into sea or lake;

the sun astride the hills, or rainfall

teeming down aslant between them;

a charming girl, shy but ready with her finest favours...

oh, these are dear and lovely things to lose.

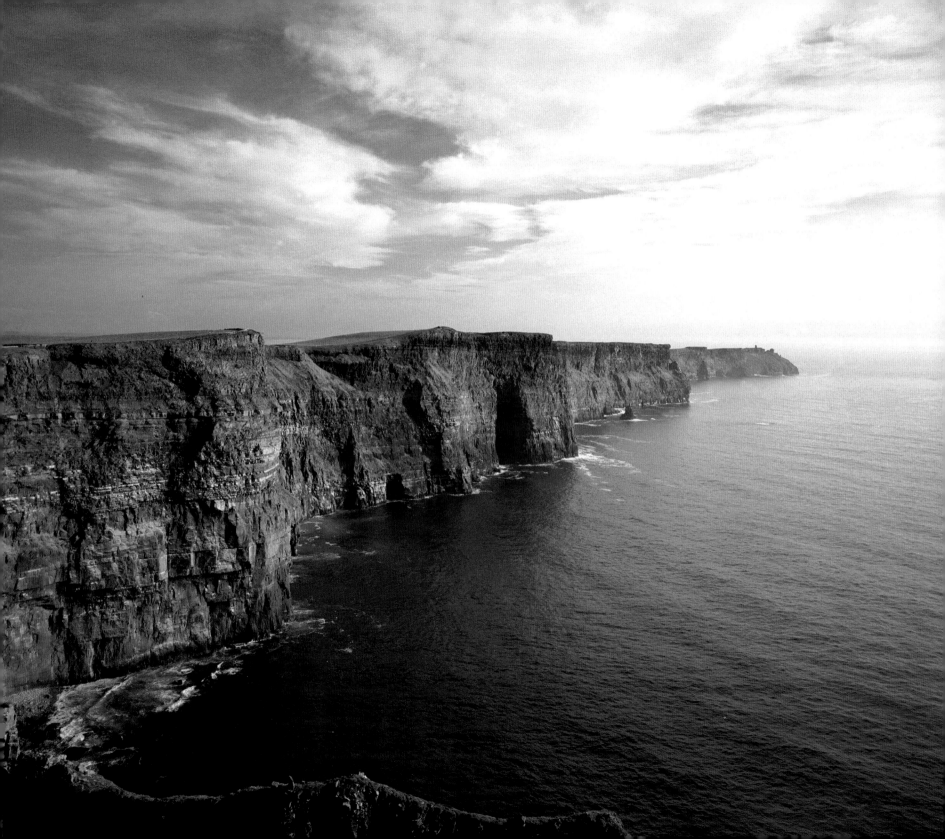

*H*ush!

Be simple, reverent, and understanding;

and above all, be silent.

The slightest touch or twinge of a question here

provokes disturbance in the ensurance of calm and contemplation.

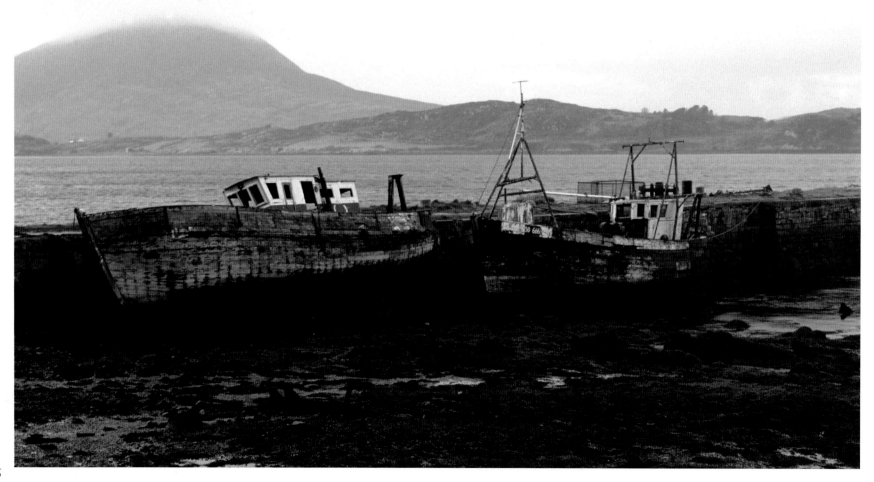

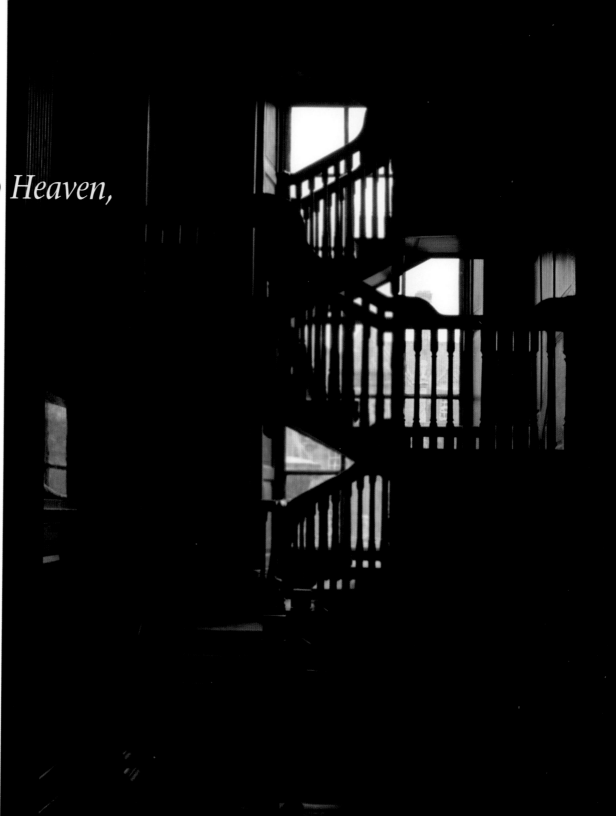

*I*f I ascend up to Heaven,

He is not there;

if I make my bed in Hell,

there is no sign of Him;

if I take the wings

of the morning,

and dwell in the uttermost

parts of the sea,

even there shall

no eye behold Him;

neither shall any hand

shoot up to shade

startled eye from

a sudden light.

The darkness and the light

are both alike in emptiness.

\mathcal{A} sense of beauty

at the sudden sight of some image; image of cloud, flower, fern, or woman, lingers less than a moment.

Silence the sigh, for man has made many an everlasting thing out of a moment of time.

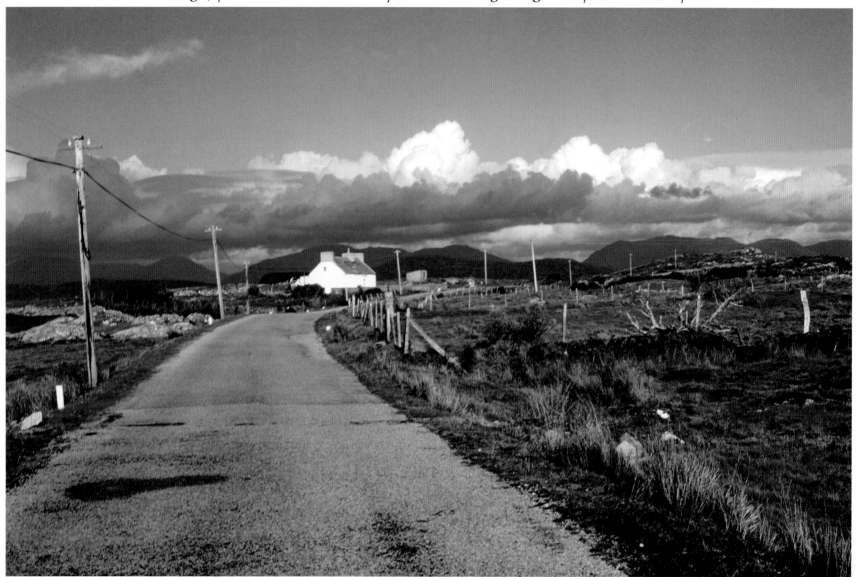

*H*ere, here, said the voice

under the plumed hat, that only stands to reason,

an' it's my opinion, an' I don't care who knows it,

that th' Garden of Eden was somewhere among

the lakes an' fells of Killarney.

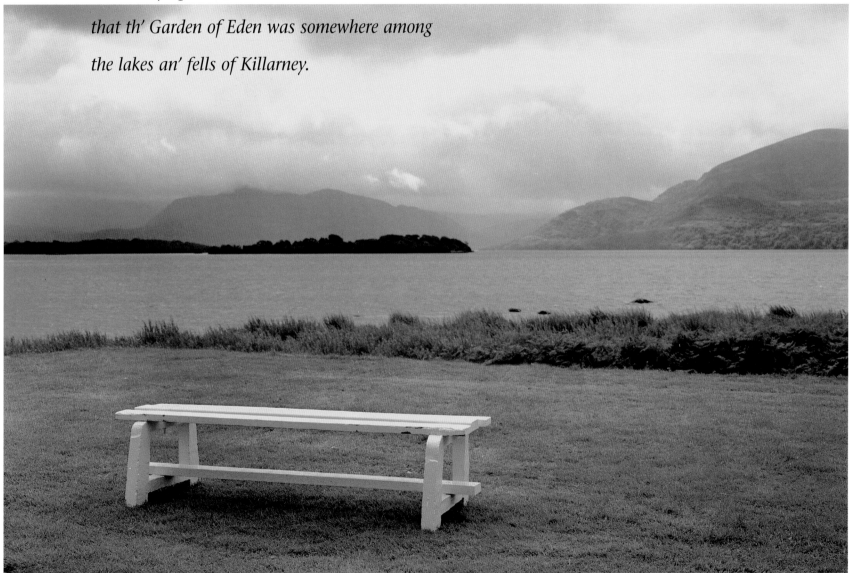

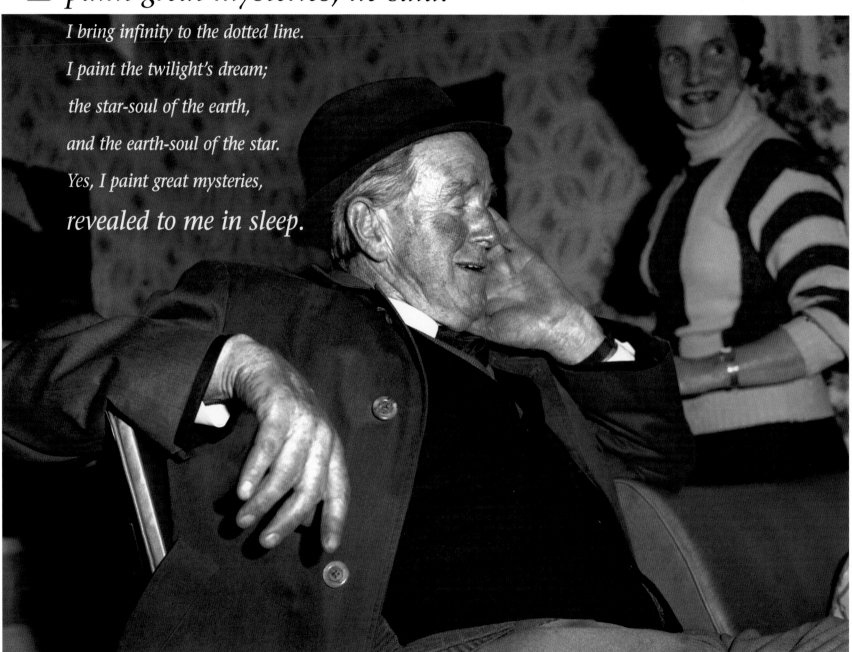

I paint great mysteries, he said.

I bring infinity to the dotted line.

I paint the twilight's dream;

the star-soul of the earth,

and the earth-soul of the star.

Yes, I paint great mysteries,

revealed to me in sleep.

*H*ow quiet the house had grown.

Not a mouse stirring.

He had never sensed the house so still before, as if the life had gone, and left it breathless.

Quieter than a nun, breathless with adoration; as still as death itself.

He shivered as if a creepy silent wind had entered the room; cold, as cold could be.

As cold as heaven would be if God cast a cold look on a well-loved saint.

*A*way in a sacred spot of the garden, a magnificent

copper beech swept the ground with its ruddy branches, forming within them a tiny dingle of its own. This

was the sacred tree of Coole. On its trunk were carved the initials of famous men who had come

to visit Coole, so that they might be remembered forever. The initials of Augustus John were there,

and those of Bernard Shaw and Yeats were cut deep into the bark that looked like hardened dark-red velvet.

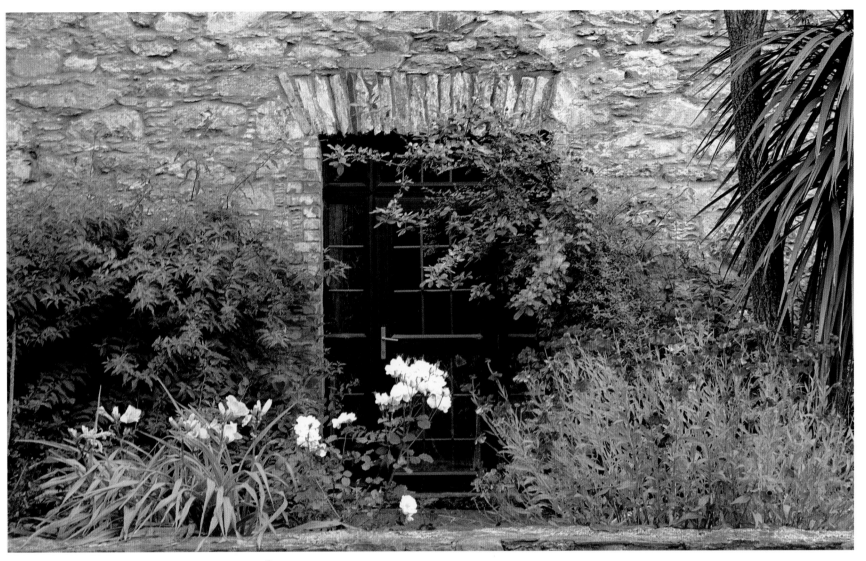

...*W*here many a lovely, youthful

rose crinkled into age, and died at last in peace, where three parts of the year was

a floral honeymoon — here the dust and the mire came too,

and quiet minds knew ease no longer.

A day ago, here was all the knowledge, all the fear, all the hope the world wanted. Life was fashioned so that all was ordered, stately, trim, triumphant, cut out and braided as deliciously as the sacerdotal garments of the High Priest about to enter the holy of holies, down to the last little bell and pomegranate nestling among the fringes. And poor Archbishop Ussher insisting that the universe was but a child of four thousand years of age, and Dr. Lightwood, going farther, light-headed with the discovery, added that it was all created on the 23rd of October, at nine o'clock in the morning.

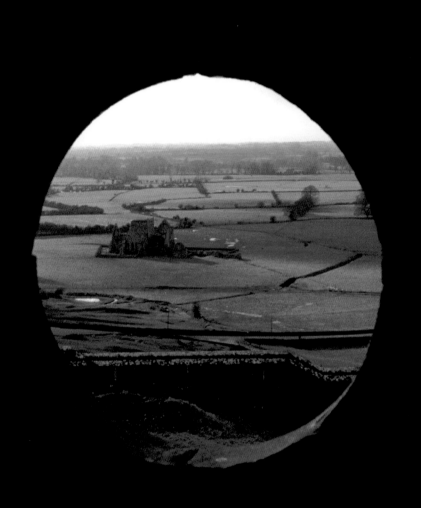

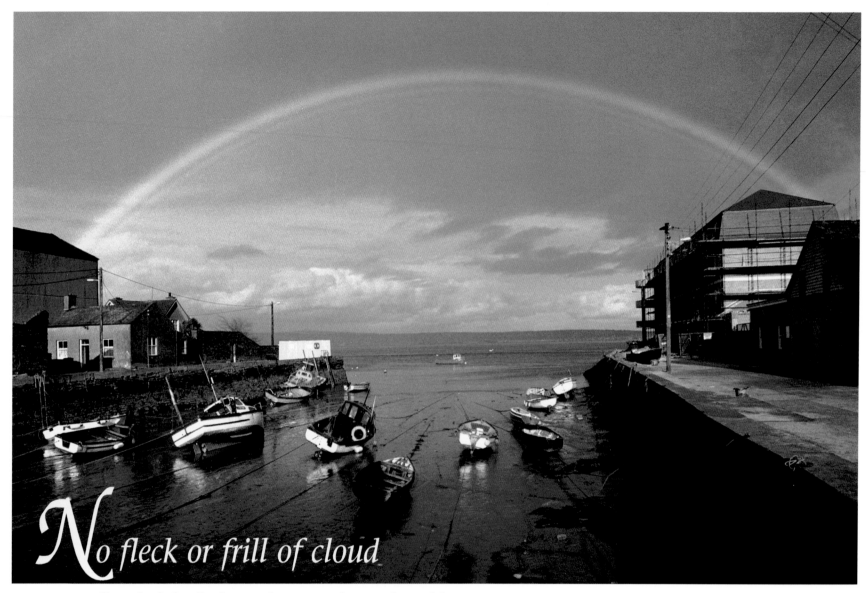

No fleck or frill of cloud

disturbed the freshness that must have adorned it

when the sky first came into being.

It was as if God, in a giving vein,

had draped the sky in a birthday cloak.

*P*erhaps God would conjure up in a distant corner

a radiant image of a cozy pub where Tom and his Fusiler butties could for ever drink without drinking,

fight for ever without fighting, and die for their Queen and country without dying at all,

and gather a harvest of glittering medals on their chests to show themselves off to the wondering saints.

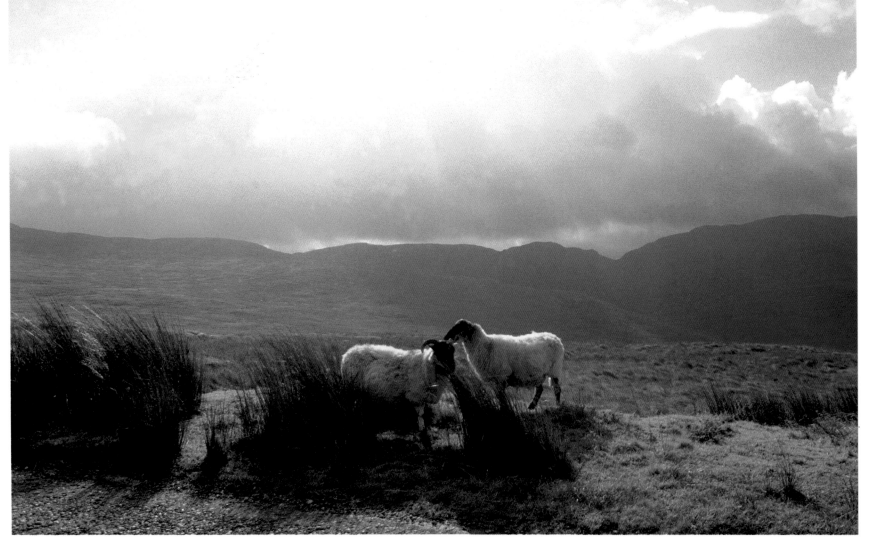

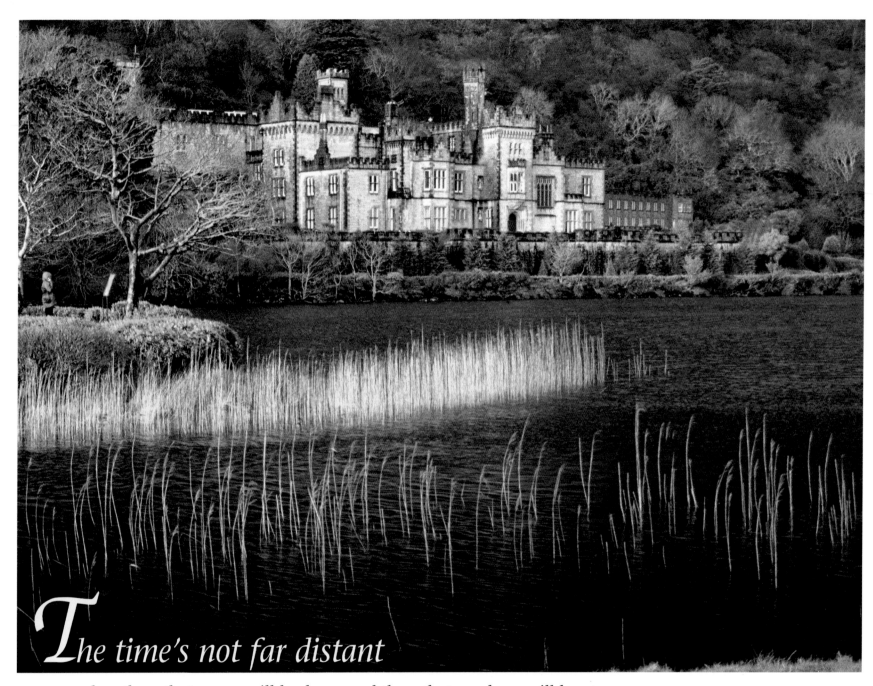

*T*he time's not far distant

when them that are up will be down, and them that are down will be up,

and your grand Viceregal Lodge will be no more...

...that's herself...me own daughter...

who could hold a lily to one cheek

an' a rose to the other

without makin' either feel outta place...

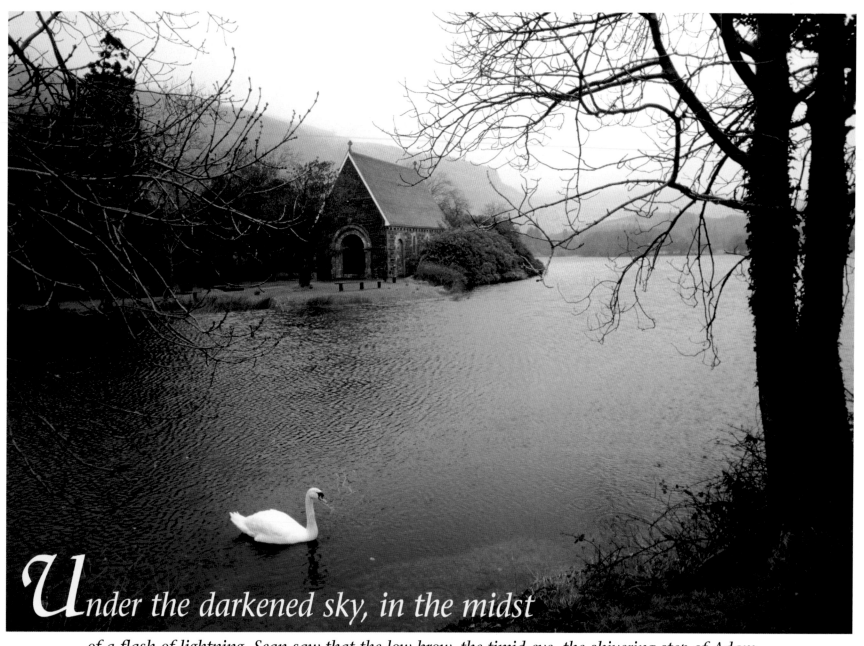

Under the darkened sky, in the midst

of a flash of lightning, Sean saw that the low brow, the timid eye, the shivering step of Adam

had changed to the alert walk, the gleaming eye, the lofty brow, and the reddish thrust-out beard

of Bernard Shaw. And Sean, bending low under the Golden Bough, followed close behind him.

*T*hey had many things

in common besides

the theatre.

He loved pictures...

She loved good books...

She saw humour sparkle

from things thought

to be dead, or dull,

and so did he;

and they often

talked and laughed

together over tea

in a hotel that

overlooked the

fair form of

Stephen's Green...

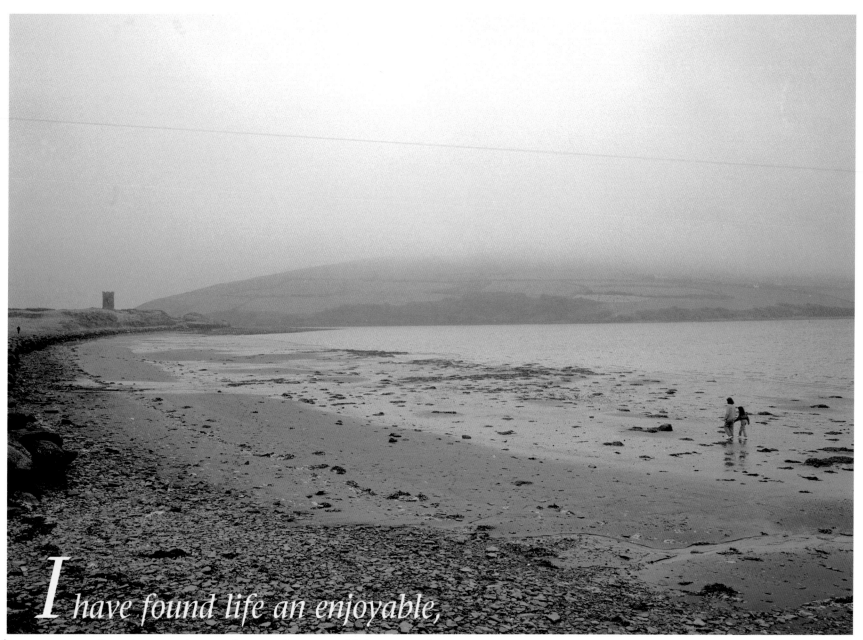

I have found life an enjoyable,

enchanting, active and sometimes terrifying experience,

and I've enjoyed it completely.

A lament in one ear, maybe, but always a song in the other.

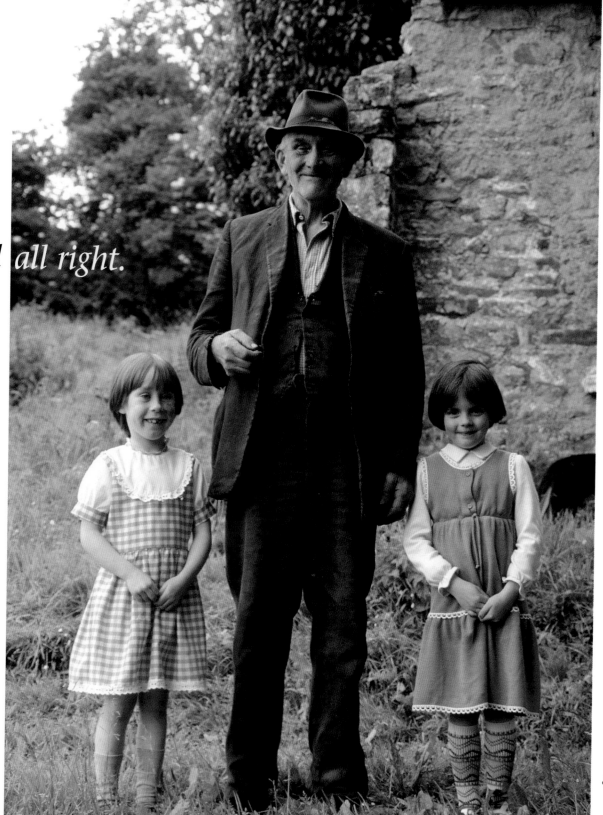

God, he felt proud all right.

Felt as proud as he did
when he first fell into step
with Shakespeare.
His body was now
in fine alignment
with his mind.

We could almost walk as quick,

said the Rector impatiently;

and that remark fell softly into the silence that had gone before it.

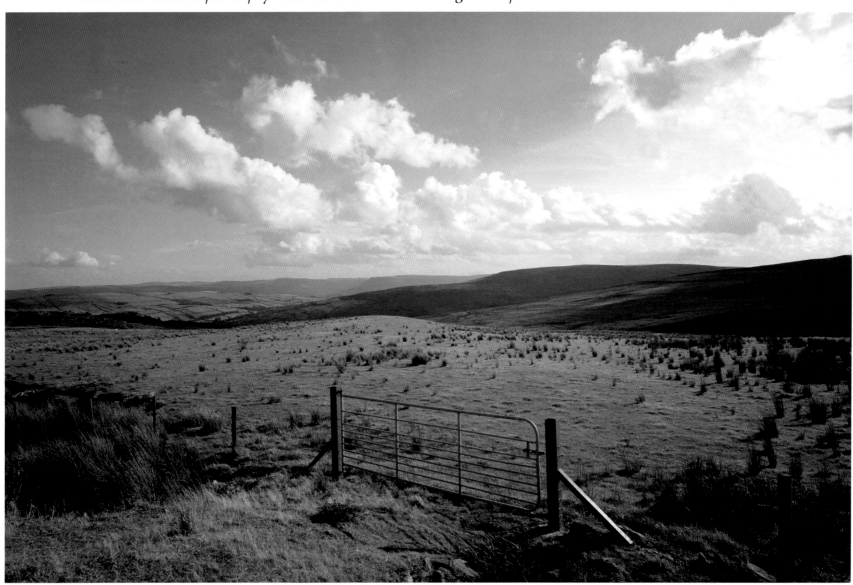

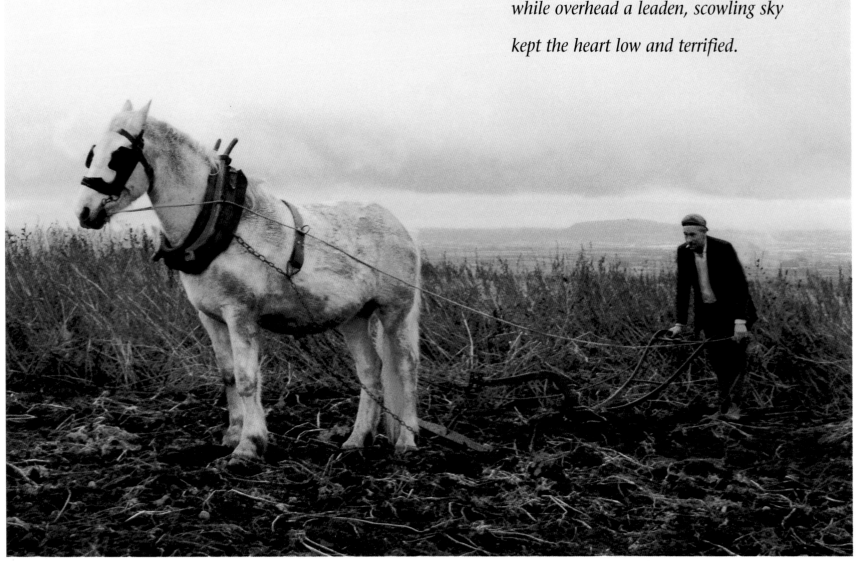

*A*ll the colours of the land

before him were gloomy browns,

sad greens, and fading purples,

while overhead a leaden, scowling sky

kept the heart low and terrified.

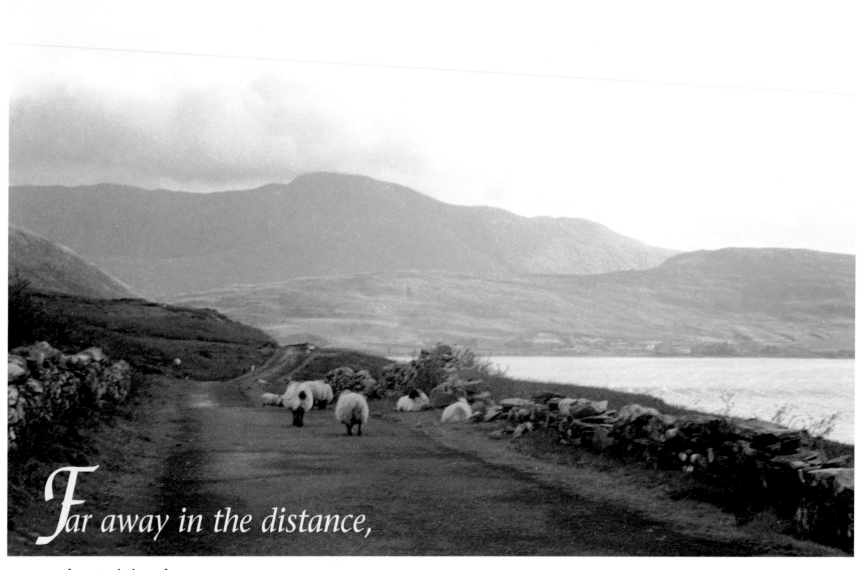

*F*ar away in the distance,

by straining the eyes,

one could see the place was ringed round by dark shapes like mountains,

like giant guardians watching that nothing went too far from where nothing was.

Everywhere the drums

beat again their lusty rolls, making the bright stars in the sky quiver,

and bands blew Ireland's past into every ear.

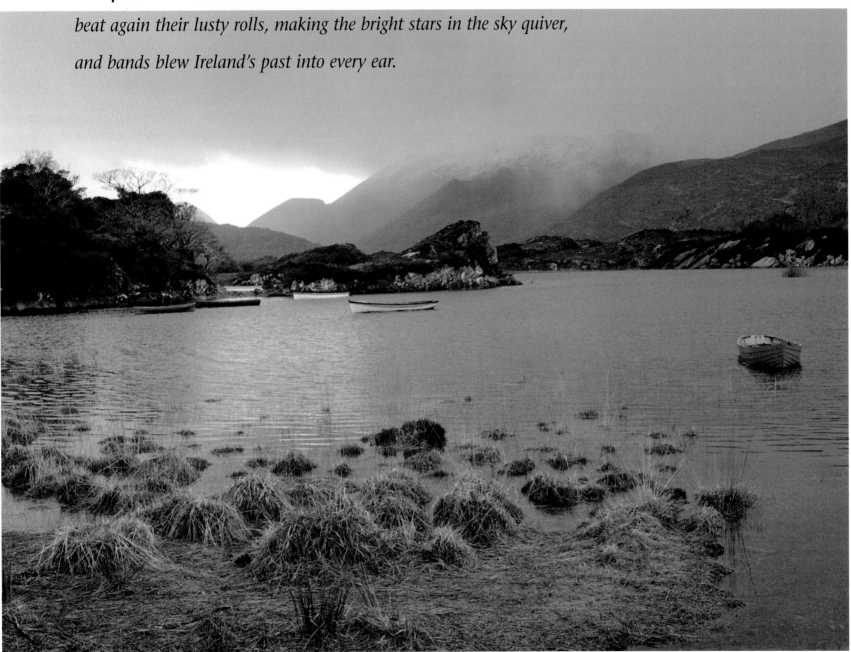

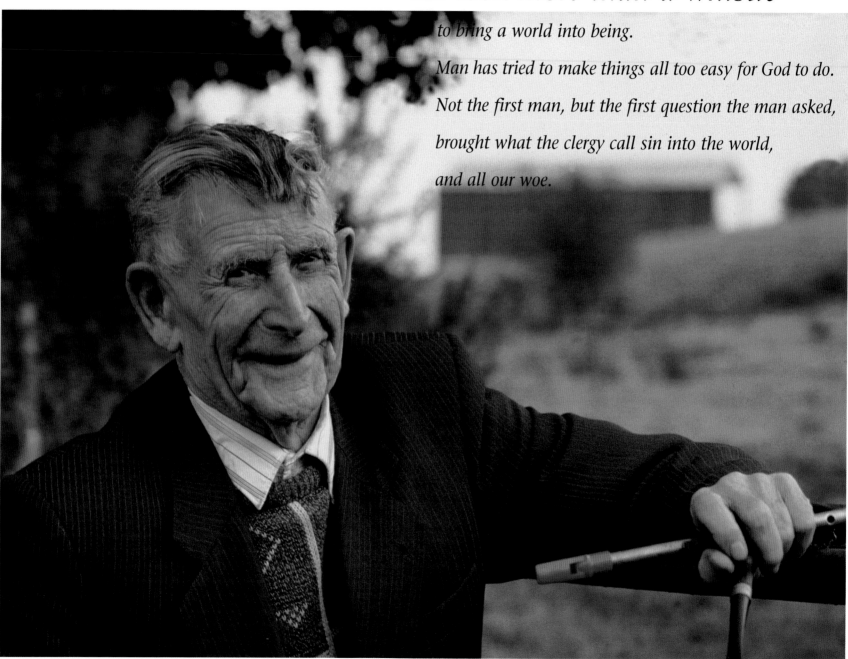

It took more than a whistle

to bring a world into being.

Man has tried to make things all too easy for God to do.

Not the first man, but the first question the man asked,

brought what the clergy call sin into the world,

and all our woe.

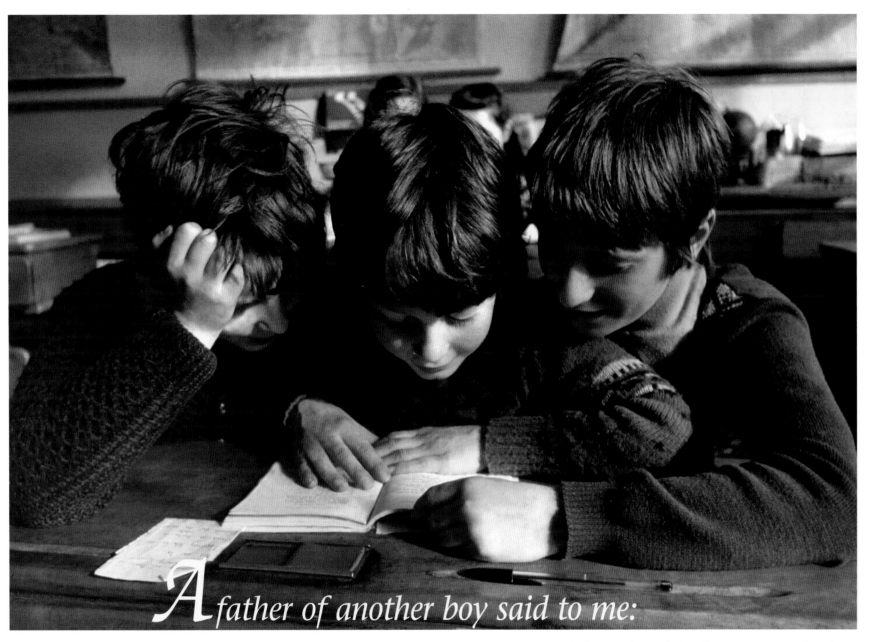

\mathcal{A} *father of another boy said to me:*

He's no good at books, no good at work; he's good for nothing but playing a tin whistle.

What am I to do with him?

And the distressed father was shocked by Pearse saying: Buy a tin whistle for him.

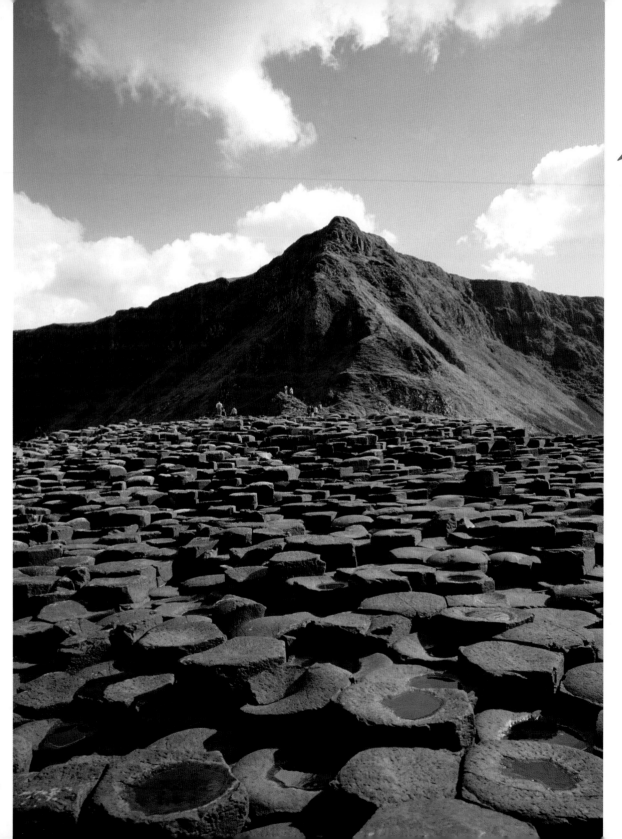

Look here, boys,

I love the Irish;

I've learned a lot;

I want to spend a holiday

in an Irish district,

Connemara for preference,

but I've no money;

couldn't you people

fork out enough to fix me

there for a week or two,

so that my Irish

may be as the rain falling

on the earth,

or the lightning splitting

the black clouds?

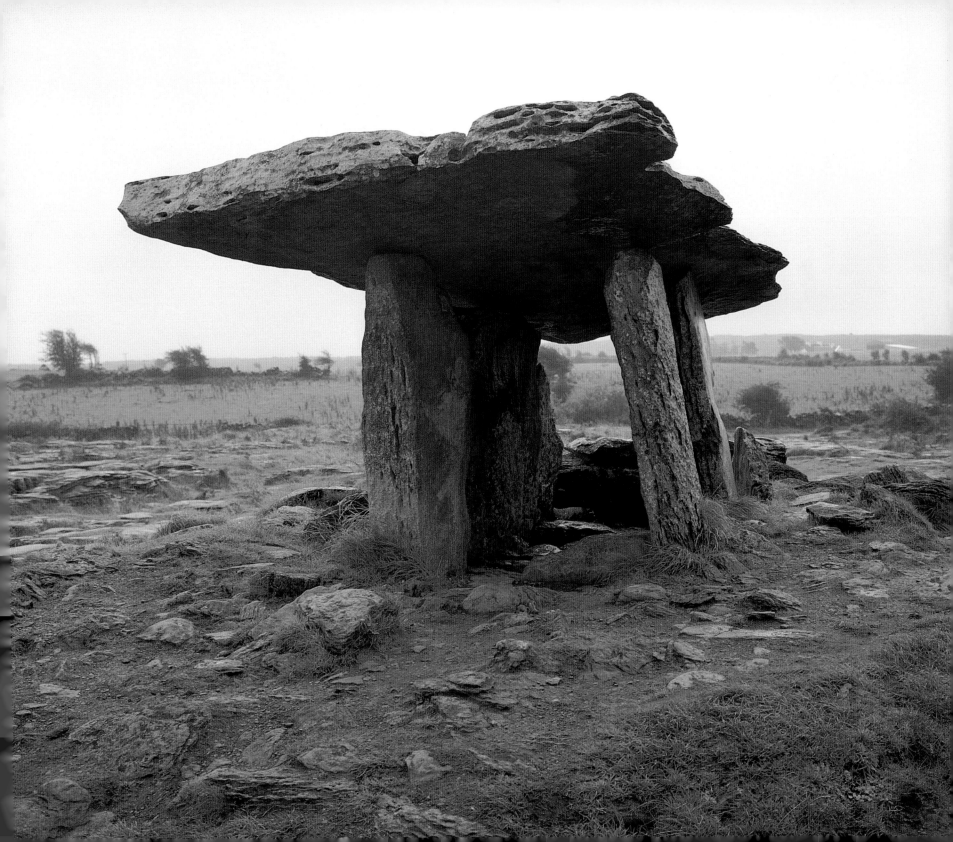

The one lovely thing about the whole place,

thought Sean, is the sky. A purest blue. In it was some of the darkest blue,

and all of the gentle blue of the lightest blue forming a luminous and radiant blue of its own.

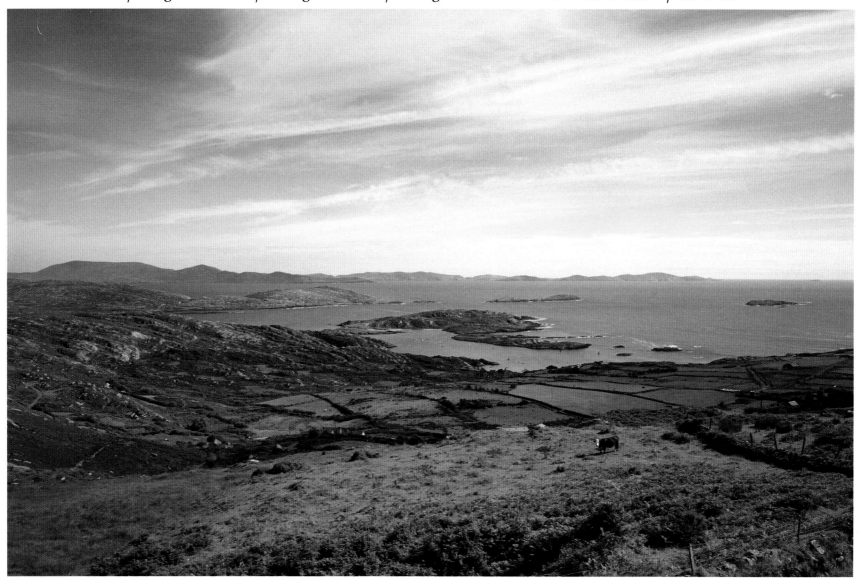

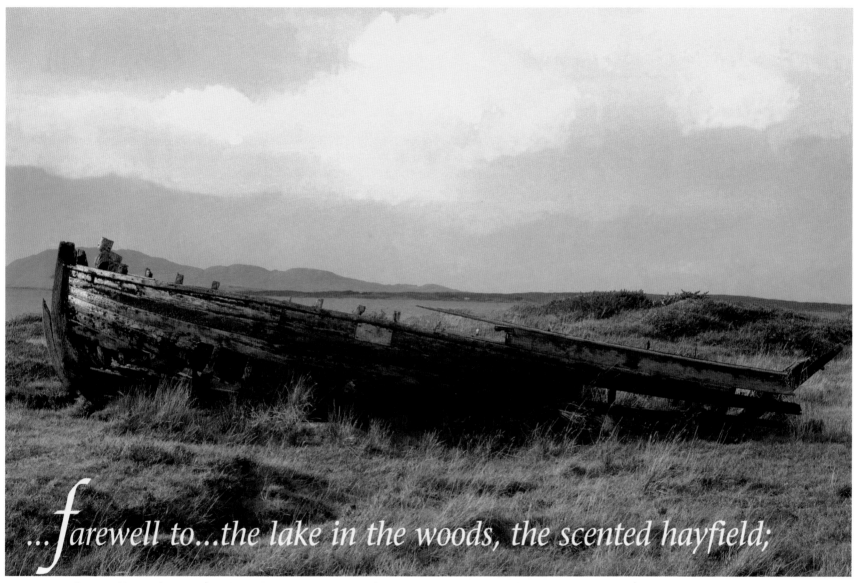

...farewell to...the lake in the woods, the scented hayfield;

farewell to the azure sky, the brown bog, the purple heather of Connemara;

farewell the pageants that wheeled broad palaces into simple places and turned greyness into magic colours;

farewell the jewelled quaintness in the thoughts and play of children.

Oh, farewell! The moments have grown bigger than the years.

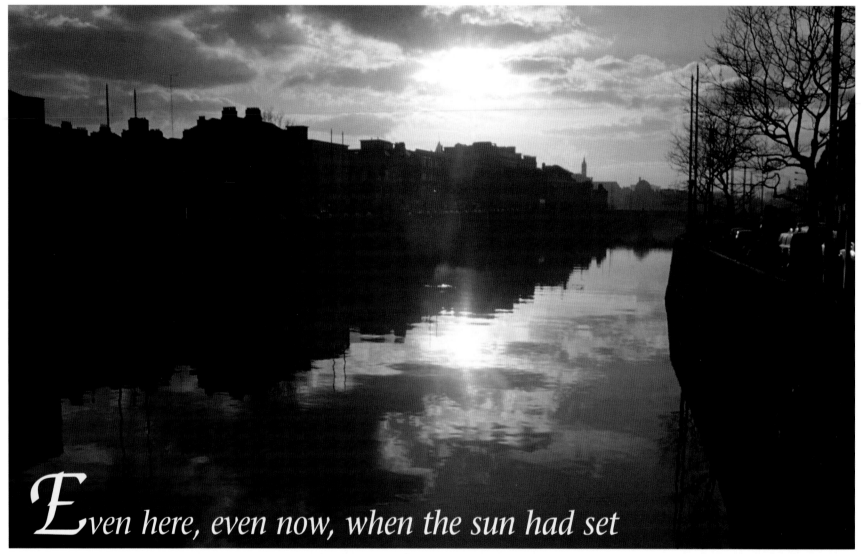

Even here, even now, when the sun had set

and the evening star was chastely touching the bosom of the night, there were things to say, things to do.

A drink first! What would he drink to — the past, the present, the future? To all of them! He would drink

to the life that embraced the three of them! Here, with whitened hair, desires failing, strength ebbing out

of him, with the sun gone down, and with only serenity and the calm warning of the evening star

left to him, he drank to Life, to all it had been, to what it was, to what it would be. Hurrah!